電影道具大師設計學

偽情書、假電報與越獄地圖、電影道具平面設計；
置身電影幕後，一窺平面道具非凡而細緻的設計

Fake Love Letters, Forged Telegrams,
and Prison Escape Maps
Designing Graphic Props for Filmmaking

安妮‧艾特金斯（Annie Atkins）
劉佳澐／譯

推薦序

傑夫‧高布倫
二〇一九年七月十日
Re：偽情書、假電報與越獄地圖

親愛的讀者：

　　觀賞魏斯‧安德森的電影如同一場沉浸式體驗。從電影的第一幕開始，你便已經進入他充滿想像、神秘而又奇異的世界裡，但場景中卻依然留著我們尋常的物件、顏色與一股熟悉感。

　　安妮‧艾特金斯正是這方面的頂尖職人。魏斯慧眼識人，找來安妮為他將最根本的情感脈絡，融入那超凡的電影世界裡。她設計了許多令人驚艷的道具和日常小物，其中總有她獨特的風格與審美。安妮讓這些道具看起來更加逼真，又讓逼真變得更加生動，並且始終充滿魔力。

誠摯地，
傑夫（Jeff Goldblum）

JEFF GOLDBLUM

July 10, 2019.

Re: FAKE LOVE LETTERS, FORGED TELEGRAMS,
AND PRISON ESCAPE MAPS.

Dear Reader:

Watching a Wes Anderson movie is a
total-body experience. From the first
frame, you immediately enter a world ripe
with fantasia, mystique, and otherworldliness
yet still remain amid objects, the palette,
and feelings of the familiar.

Annie Atkins is a master craftswoman in
this regard. Under the knowing eye of Wes,
Annie coaxes the transcendental into a
meat-and-potatoes emotional logic. Her
designs encompass the extraordinary and
ordinary but with a feel and aesthetic
all her own. Annie makes the unreal seem
hyperreal, and the real more supremely
alive and utterly magical.

Sincerely,

Jeff

序

「使者」（herald）是一種故事創作的原型（archetype），通常指的是足以驅動劇情的一段訊息，或者是一位傳遞訊息的人物。比如說，在一部以九〇年代為背景的電影中，主人翁收到了一封緊急電報，或者某個更古老的時代，國王拋出了一份卷軸，角色於是展開了行動。也可能是在一部八〇年代的浪漫喜劇裡，女主角回到她堆滿雜物的公寓中，並按下答錄機的播放鍵，劇情便得以推進。「使者」可以是一件物品，也可以是個角色，像是在《饑餓遊戲》（The Hunger Games）中，艾菲在台上宣佈，十二歲的小櫻必須參加遊戲且廝殺至死，才有了接下來的故事。還有，當數百封信從壁爐裡飛出，哈利·波特便知道他勢必要前往霍格華茲了。無論「使者」是哪一種形式出現，它在劇情中的功能都是要告訴故事主角，就算百般不願，他們的生活都即將發生難以想像的變化。對於所有故事來說，這都是一個非常重要的元素，對吧？如果角色始終安全地待在舒適圈裡，想必不會有人想聽這樣的故事。

許多人都認為，故事中的「使者」通常只是一張紙，例如電報、報紙頭條、十萬火急的情書等等，正是這些書面的訊息邀請主角踏上接下來的冒險旅途。而身為一位電影平面設計師，我對這種評價頗有微詞，因為「一張紙」正是我整個職業的根本。在電影的美術部門，我們通常不會使用「使者」這個專有名詞，畢竟敘事工具是編劇的範疇，但我們確實會使用「主角」這個詞：「主角道具」（hero prop）是必須受到鏡頭檢視的作品，並在故事中佔有一席之地。有人能以設計一張紙當成職業，甚至還是一份全職的工作，這聽起來似乎不太可能，但只要去看看電影中一些不可或缺的平面道具，就能對這個職位略知一二。像是，《七寶奇謀》（The Goonies）的兄弟們是在發現了藏寶圖之後才展開尋寶，《巧克力冒險工廠》（Charlie and the Chocolate Factory）的查理必須獲得金獎券才能參觀工廠，而在《搶救雷恩大兵》（Saving Private Ryan）中，一位辦公室職員發現，自己經手的三封弔唁信都寄發給同一位母親，於是才有了搶救二等兵的行動。

犬
反対
（Anti-Dog）

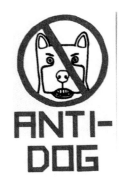
ANTI-
DOG

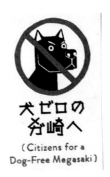
犬ゼロの
分崎へ
（Citizens for a
Dog-Free Megasaki）

NO TO

DOG

犬反対 NO DOGS

犬ゼロの
分崎へ
（Citizens for a
Dog-Free Megasaki）

犬反対
（Anti-Dog）

うんざり?
（Fed Up?）
ゴミ島条例
賛成
（Vote Yes to
Trash Island Decree）

反犬派の学生
（Students Against Dogs）

犬反対

（No to Dog）

《犬之島》的抗議標語

平面道具有時需要複雜而冗長的設計過程。在《歡迎來到布達佩斯大飯店》（The Grand Budapest Hotel）中，由於門僮季諾是在報上讀到德夫人的訃聞，所以我們必須製作出一份完整的全國報紙。而在《犬之島》（Isle of Dogs）裡，我們打造了許許多多抗議布條來展現人群的怒火，上面的日文字都是用膠帶貼成的。這些道具也可能是任何微不足道又極為簡單的東西，任何場景中出現的文字，無論字體多麼樸素，字數多麼少，通常都也是一種「平面設計」。在瑪麗‧哈倫（Mary Harron）執導的《美國殺人魔》（American Psycho, 2000）中，遞名片的橋段現在已經成為了經典，更是一段與設計息息相關的對話，這在電影中十分少見，畢竟很少會有電影角色談論平面設計。「昨天才印好的，」貝曼說著，一邊將他的新名片放在會議桌上。他正是劇中的殺人魔。「骨白色，」他得意洋洋地說，指的是紙張的顏色，「字體是西利安萊爾。」然而，同事們的優越感卻明顯動搖了貝曼的氣勢。望著其他人的名片，他感到喉嚨發乾，而他的反應更加凸顯出名片質感的懸殊：「看看那低調的灰白色，和充滿品味的厚度。天啊，竟然還有浮水印！」這些名片是劇組的美術部門製作的，而且為了增加場面的幽默感，它們被設計得極為相像，很難辨別出差異。貝曼的名片上其實是一種名為「Garamond」的襯線字體，至於「西利安萊爾」，則完全是原作小說作者布雷特‧伊斯頓‧艾利斯（Bret Easton Ellis）所虛構的。

在潘妮‧馬歇爾執導的《飛進未來》（Big, 1988）中，十三歲的賈許個子太矮了，無法和朋友一起搭上遊樂場的雲霄飛車。當他看到了那台名為「佐爾塔」的古董許願機時，他立刻許願希望自己快快長大。精靈發出低吼，雙眼發光，一張小小的卡片從機器裡彈了出來，雖然賈許發現許願機根本沒有插電。卡片正面寫著：「佐爾塔指點迷津。」而背面則是：「你的願望實現了。」接著小賈許離開，一夜之後，他成了由湯姆‧漢克斯（Tom Hanks）飾演的三十歲大賈許，生活也從此發生了難以想像的變化。這張卡片就是一種「主角道具」，而在特寫畫面中，卡片上的文字正是經過細心設計的嘉年華風格手寫字體。試想，如果文字只以全大寫的「Helvetica」字體來呈現，似乎就不太可能展現出同樣詭譎的氛圍了。

Your Wish is Granted

《飛進未來》的許願機卡片

這張卡片是經典的平面道具，出自我童年最愛的其中一部電影。三十年來，它一直被保存如新，收藏在電影搭景師喬治・德蒂塔（George DeTitta）家中地下室的一個塑膠資料夾裡。

這些簡單的小物總設計得與電影十分相配，並被放在最適合的畫面中，看似不經意，彷彿本來就已經存在，只是剛好在當地市集的某個角落被拍到，讓你不禁以為，說不定這架古董許願機早在電影劇本寫好之前，就一直放在那座遊樂場裡？事實絕非如此，雖然它在這座樂園裡扮演著這麼重要的角色。本片的搭景師喬治·德帝塔（George DeTitta）和蘇珊·博多·泰森（Susan Bode-Tyson）回憶道，這台許願機是特地為這部電影打造的，並由美術指導（art director）史畢德·霍普金斯（Speed Hopkins）設計，並由兩位道具師傅在他們的曼哈頓工作室中製造完成。他們將許願機的外箱製作得很大，好讓道具操控員可以躲在裡面，像操偶師一樣控制精靈的臉部動作。而當賈許的願望實現時，操控員就會悄悄地將卡片丟進取卡槽中。雖然現在已經無法聯繫上這兩位師傅，但或許還能憑長相來認出他們——他們顯然對於這件道具太有熱誠了，竟比照自己的長相來製作佐爾塔呢。

在這部製作於一九八〇年代的電影中，平面設計師的名字並沒有出現在片尾字幕上，因為當時美國佈景設計師協會（United Scenic Artists）還未正式認可平面設計師這個角色。從基本面來看，平面作品可以指任何帶有文字、圖案或圖片的物品，而這類道具通常會由美術部門多位的同仁經手。過去，道具上的平面圖案大多是由部門裡的實習生或助理美術指導負責處理。在美術部門擁有電腦之前，平面圖案都是純手工繪製，如果要呈現出專業印刷的效果，那就得先用辦公室的影印機將字體放大印出來，然後再以乾式轉印的方式來呈現在道具上。當時也有部份道具會外包給印刷廠，或者依照需要去請求贊助和商借。一位住在紐約搭景師回憶道，一九九〇年代，假如你需要用到房屋外面的待售標誌，可以打電話給當地的房屋仲介，並開車去向他們借用一個下午。不過，隨著版權訴訟案件越來越多，業內也對此越來越焦慮，於是，平面設計師就成為劇組的必備班底了，畢竟他們能夠製作出原創道具，且成品又合法歸屬於製片公司。

當然，現在的電影還是會使用一些真正的品牌商品當作道具，不過它們全都必須經過漫長的版權審核過程，直接自製會更有效率，也更不受限制。雖然有時影片中確實會出現一些真正的商品，但這大多是出自劇組的創作選擇，好讓電影更加貼

近當時當地的情境。不過，這種做法並不等同於產品置入。所謂的產品置入，是指由品牌贊助部份的電影製作預算，藉此讓他們的商品或作品出現在電影裡，而這可能會影響或決定劇組要如何拍攝這件物品，或者這件物品何時會出現在鏡頭之中。大多數的導演並不願意為了額外的金錢而犧牲故事的完整性，或者容忍品牌干擾創作過程。因此，假如你在電影背景中看到某個你認識的品牌，多半是因為電影根據真實事件改編，或者想要呈現出類似真實事件改編的風格，而美術部門尋求品牌的同意，以這些物品來打造出更有真實感的背景。在由勞勃·辛密克斯（Robert Zemeckis）執導的《浩劫重生》（Cast Away, 2000）中，一位送貨員的貨機在南太平洋墜毀，因而被困在一座荒島上。雖然男主角查克是一個完全虛構的角色，但他的經歷卻十分有真實感。或許有一部份要歸功於本片編劇威廉·布洛勒斯（William Broyles Jr.），他在為劇本進行研究的期間，真的跑去住在一座無人島上。但另一部份原因，則是電影裡幾乎所有的貨物道具都屬於「聯邦快遞」（FedEx），這是真實世界中最知名的品牌之一。

現在，幾乎所有電影或影集的劇組中，都至少會有一位專業的平面設計師，有時甚至多達三到四位，視製作預算和電影主題性質而定，比如說，以農場為背景的電影和以新聞編輯室為背景的影集相比，所需的平面設計勢必就會少很多。雖然平面設計師最終目標是要完成導演和藝術總監（production designer）對影片的整體期望，但我們的日常工作更常是在製作各種小道具，並交付給相關部門的主管，例如，為搭景師做出報攤上陳列的雜誌，為美術指導繪製好房屋上的店面招牌，或是做出一本本護照，讓道具管理員（property master）分配給演員們。平面設計的範疇也包含用於襯托佈景的「裝飾製作物」（dressing graphic），還有「場景製作物」（construction graphic），是佈景中的各種小物，以及「情節製作物」（action graphic），會被交到演員手上，甚至出現在特寫鏡頭裡。不過哪些製作物分屬於哪個美術部門，這目前可能還是灰色地帶，比方說，壁紙究竟應該是製景部門的預算，還是應該由佈景組來支出？這些問題沒有固定的答案，每個電影劇組的工作流程都不一樣，規矩也不同。但無論如何，在一部電影的設計中，藝術總監和搭景師永遠是兩個最重要的角色，他們也是最終會上台領奧斯卡金像獎的人。

為了創作出逼真的道具，平面設計部門可以在製作過程中，尋求書法家、手寫創作者、裝幀師或網版印刷師等其他手工創作者的協助。畢竟數位印刷字體永遠無法取代手寫字，手繪標誌也很難被印刷看板替代。設計師們除了會花許多時間來研究早期的製作方法和風格，在開拍前數周的準備時間裡，也會造訪劇本中所描述的地點，或沉浸在時代背景的氛圍之中。所有的道具和佈景都必須建立在真實的基礎上，就算是最怪誕的電影，也要以真實感為根基。雖然這些道具總被做得難辨真偽，但事前一定會參考真實歷史中的物件，才能設計出逼真的作品。

　　然而，逼真的道具和真實的物品仍然是完全不同的。雖然我們會參考真實物品獲得靈感，但這不表示我們堅守寫實主義。由貝瑞特・奈魯利（Bharat Nalluri）執導的《聖誕頌歌》（The Man Who Invented Christmas, 2017）上映之後，網路上曾掀起一陣熱議。當時其中一張劇照上，狄更斯正在閱讀一份十九世紀的報紙，而頭版上有個醒目的大標題。一位歷史學者就在Twitter上發文，說這完全不符合時代背景。原來，十九世紀英國的報紙首頁，通常放的是各式各樣的小廣告，而不是新聞報導，一直到二十世紀中期，頭條新聞標題才首次出現在《泰晤士報》（The Times）的頭版上。我們固然能夠理解，這位歷史學者是因為史實未被重現而感到很失望，但電影美術部門的工作有時也不應該被以太過寫實的方式看待，因為我們還是需要一些創作上的取捨。如果要重現當時的報紙最真實的樣貌，那麼放在內頁的新聞報導尺寸，勢必會小到任何相機都難以在中景鏡頭（mid shot）中捕捉到畫面。而劇組選擇將斗大的新聞標題放在首頁，則可能是因為那是視覺敘事過程的重要部份。比如說，我們該額外花費一百萬美金，把戰爭場景如實拍攝出來，還是直接讓角色在報紙上讀到戰爭的消息就好？若要讓觀眾先行理解故事的背景資訊，頭版標題可能是最快速又有效的方式，因此，多數導演這時候會選擇捨棄精確的真實歷史，選擇去講好一個故事。畢竟他們並不是在拍一部關於十九世紀報紙排版的紀錄片。

　　不過，這也並不表示精確的平面道具就無法製造出巨大的戲劇效果。在英國ITV的古裝劇《唐頓莊園》（Downton Abbey, 2010）第一集中，報紙道具就被用

來宣達了當時最重要的大事，也就是鐵達尼號沉船了。這份報紙看起來就像是一九一二年四月十五日《泰晤士報》的復刻版，而且頭版上沒有任何大標題。編劇們選擇將道具融入劇情橋段，循序漸進地揭開新聞大事，同時也讓觀眾得以認識古代冷知識——在那個時代，任何送進鄉間豪宅的報紙，都必須由僕人先進行熨燙，才能交到貴族手中。在這個橋段中，第二男僕威廉比所有人都先讀到新聞，因為他必須將報紙攤開，一張張單獨熨燙。也因此，沈船消息在樓上的人聽到之前，就已經先傳遍了僕人的宿舍。劇組適度運用了英國大報設計史的趣味軼事，不著痕跡地將它融入了迷人的蒙太奇之中，展示出當時與現代日常之間的差異，也展展現出樓上貴族和樓下僕人之間不同的生活。至於為什麼要熨燙報紙呢？女幫廚黛西也在劇情中替我們發問了。「為了燙乾墨水，傻瓜，」有人這麼告訴她，「我們可不希望讓伯爵的雙手跟你的一樣黑。」

但我們的製作物也不見得總有現實依據可循，比如「事件板」就是一個例子，這完全是一種被設計出來的佈景道具。你一定常在電影中看到，偵探將最新一起案件的所有線索全都釘在辦公室牆上，包含了新聞剪報、嫌疑犯的入案照和當地的地圖，他們通常會用大頭釘和紅色繩子將有關係的人事物全都連在一起。這是警察真實的辦案過程嗎？現實多半沒那麼吸引人。話雖如此，電影平面設計的其中一大要點，往往是要將角色的思考形象化地體現出來，製作過程也十分需要創意。在蓋·瑞奇（Guy Ritchie）執導的《福爾摩斯2：詭影遊戲》（Sherlock Holmes: A Game of Shadows, 2011）中，華生回到他從前的辦公室，發現福爾摩斯在房間裡貼滿了報紙、照片和地圖等線索。在這個場景中，不僅僅是牆壁上釘滿了紅線，而是整個房間裡都有。「你喜歡我的蜘蛛網嗎？」福爾摩斯問道。這佈景所展示的正是他當下的精神狀態。

長期以來，許多電影的美術部門都會以細膩的製作物，來反映出虛構人物的心理狀態。福爾摩斯房間裡交錯的紅線令人想起朗·霍華（Ron Howard）執導的《美麗境界》（A Beautiful Mind, 2001），患有思覺失調的數學家者約翰·納許也有這麼一面貼滿混亂資訊的牆。而在Showtime電視網影集《反恐危機》（Homeland,

2011）第一季裡，中情局探員凱莉在辦案過程中，同樣製作了一整面事件板，用來分析涉嫌叛變的中士布羅迪。後來隨著凱莉暫停服用躁鬱症藥物，又開始與布羅迪過從甚密，她逐漸瀕臨崩潰的同時，這面事件板也變得越來越混亂，呈現出癲狂的視覺效果，以亮黃、綠色、紅色、紫色與藍色等五顏六色的軍事機密文件，拼湊成一條時間軸。究竟是她瘋了，或者這就是天才探員的辦案過程？觀眾們在兩者間不斷游移，最終選擇相信了後者，但中情局終止了她的調查，並拆除了她所有辛苦拼湊出的資訊牆，當然這也是平面設計部門辛苦製作的成果。這些「瘋狂的事件板」通常都設計得非常細緻，才能因應所有慢動作或特寫運鏡，是非常繁重的工作。

在庫柏力克（Stanley Kubrick）執導的《鬼店》（The Shining, 1980）中，傑克的精神狀態從全片開始不久後就令人質疑。他正試著完成自己的劇本，而他的家人也一起被困在那座無人飯店裡。他的妻子溫蒂躡手躡腳地走向傑克棄之不顧的打字機，發現他整疊草稿上盡是徹底的瘋狂。這整份草稿全都重複著「只工作不玩耍，是人都會變傻瓜」同一句話，接著全片便進入最後的恐怖高潮。溫蒂手上這本厚達五百頁、精心編排的草稿，更是直接證明了主角已經完全發瘋了。庫柏力克從沒說過究竟是誰打了這五百頁，有人說是他親力親為，將打字機設定好，能夠重複跳出同樣幾行文字。某些認識他的人認為，這確實很像他會做的事。只不過，在定格鏡頭中，我們可以看到每一行的空格不一，因此片場的另一個謠言應該更有可能才是真相：是劇組的秘書和辦公室裡其他幾位打字員，一起為導演製作出這些草稿。

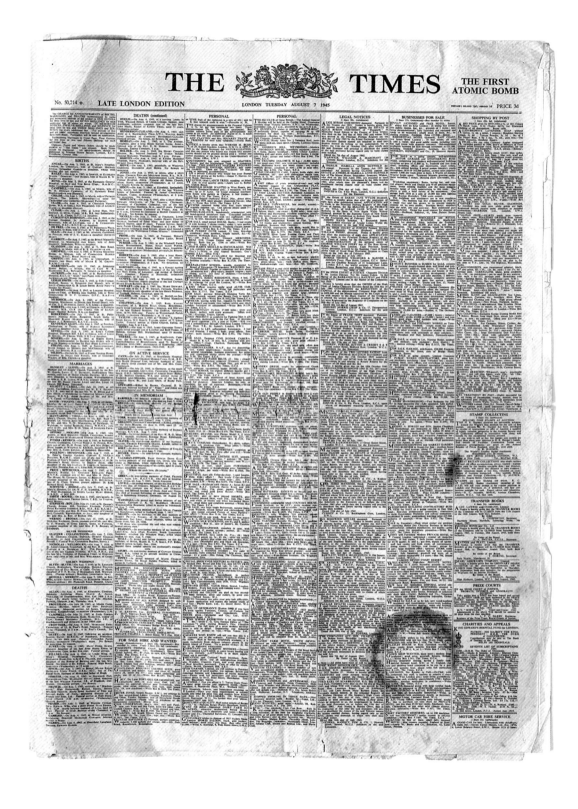

英國《泰晤士報》（THE TIMES），一九四五年

英國大報直到二十世紀中期才在頭版刊登新聞報導，在那之前，頭版上放的都是各式各樣的小廣告。

自二〇〇四年起，庫柏力克的電影製作物展覽便在世界各地的藝廊巡迴展出，其中大部分的製作物都是他過世之後在他家中找到的，當然也包含傑克這份「劇本」。確實有許多導演都會保留電影中的主角道具，據說佐爾塔許願機也一直放在潘妮・馬歇爾導演家裡。劇組通常會舉行拍賣會，希望藉此回收一部份製作預算，有些道具倉庫會買走這些製作物，重新翻新再利用。偶爾，工作人員也可能會帶走一兩件他們參與製作的作品，我就親眼看到《浩劫重生》那顆「威爾森」排球本尊，放在道具管理員羅賓・米勒（Robin Miller）的書架上。我自己的工作室裡也自豪地展示了幾個《歡迎來到布達佩斯大飯店》中，門爾德斯甜點店的粉色紙盒。不過令人難過的真相是，除非有哪位心地善良的搭景師願意把所有東西都帶回家收藏，大多數的製作物最後都會被扔掉。尤其紙張在佈景中特別難以生還，灼熱的燈光和演員汗濕的手很快就會損壞這些製作物，最後這些物品往往看起來破爛不堪，無法回收再利用。有時劇組也會將這些道具送給演員們當紀念品，但沒有人知道這些東西最終會到哪裡去。據說《七寶奇謀》西恩・艾斯汀（Sean Astin）當年把那張藏寶圖帶回家作紀念，他的母親卻誤以為那是一張廢紙，就這麼將它扔進了垃圾桶。

＊

　　想到這些作品最終都被扔掉，真的很令人難過。但我自己其實也是共犯之一，我通常會在工作結束時，用最快的速度清空我的工作空間，根本不會試圖保留那些皺巴巴的製作物，它們有些可能會出現在電影裡，有些則可能被剪掉了，當下誰會知道呢，畢竟我們都得等到整整一年後，才能在電影院看到上映版本。

下面幾個章節中的道具，都是我為電影或電視劇創作的作品。它們並非全部都是主角道具，但每一件都是精心製作的，並與許多最優秀、最傑出的導演、設計師、美術指導、搭景師、插畫家、手寫藝術家和道具管理員合作，這些年來，能和他們一起工作是我的榮幸。我希望能讓讀者有機會仔細觀察這些平面道具，不僅能讓大家理解我的創作過程，也能認識現在全世界的電影平面設計師都在做些什麼。我們盡力顧好所有的小細節，幫忙建造出更大的藍圖。

第一章

細節

電影佈景往往不是我們在大銀幕上看到的那些精美構圖,事實上,它們背後充滿了電線、泛光燈,還有許多拿著保麗龍杯喝咖啡的工作人員們站在周圍。他們用逼真的小細節裝飾這個奇異的人造空間,幫助導演和演員創造出一個更貼近真實的世界,即使這些作品很少被電影觀眾注意到。

我們很難完全理解上個世紀美俄冷戰為人們帶來的恐懼。一九八〇年代長大的我，只是經歷過冷戰末期而已。我曾讀過一本茱蒂‧布倫（Judy Blume）的書，其中描寫了一些關於核彈的焦慮，也看過我哥哥買的《風起時》（When the Wind Blows, 1982），那是雷蒙‧布力格（Raymond Briggs）的繪本，描述一對退休夫婦死於輻射感染的故事，但我是以欣賞的角度來閱讀，對書中描繪的憂慮沒有太大的共鳴。就連我父母也似乎對核戰不怎麼關切，當時民間百姓的焦慮感都是來來去去的。

史蒂芬‧史匹柏（Steven Spielberg）的《間諜橋》（Bridge of Spies, 2015）以一九五〇年代末為背景，當時人們擔憂著原子彈即將轟炸紐約。唐納文一家最小的兒子羅傑對此更是備感恐懼，他在學校看了政府宣導影片《臥倒掩護》（Duck and Cover），還認真讀完大屠殺求生的宣導手冊和雜誌文章。由湯姆‧漢克斯飾演的父親詹姆士，某天發現小羅傑蜷縮在浴室地板上，手裡拿著這些報章雜誌，還在浴缸中裝滿應急用的清水，他覺得是時候和孩子聊一聊了。然而，他似乎也慢了一步，因為羅傑已經用蠟筆畫出了炸彈射程圖，從曼哈頓中心炸往他們位在布魯克林的家。

搶先讀到這樣的劇本是一種難以想像的特權。史匹柏的電影塑造了我的童年，包含《大白鯊》（Jaws）、《E.T.外星人》（E.T. the Extra-Terrestrial）、《法櫃奇兵》（Indiana Jones）、《侏羅紀公園》（Jurassic Park），以及他所有的家庭冒險電影。在我們那滿是綠地的威爾斯山谷中，並沒有太多間電影院，我們住在史諾多尼亞鄉下，距離最近的大城市更有長達五十英里的往返路程。幸好，巷子對面的鄰居有台彩色大電視、一台錄放影機，還有許多空白錄影帶。身為家中長女，每次一起看電影播出時，自然是由我負責在廣告時段起身去按下錄影暫停鍵，導致重播時，每段影片中間總會有一小段空白畫面。但我們還是不斷錄製新的電影，不斷重播，直到錄影帶用完，直到電影變得變得模糊不清。這些電影無與倫比，對四個電視兒童來說更是如此。從《E.T.》在樹林裡互相吶喊的台詞，到《大白鯊》的河邊場景，我們對每個故事如數家珍。某天，我聽到父母大吵一架，事後我母親不得

不跑來安慰我，她說了一句令人無法反駁的話：「真正的家庭生活，和你經常看的那些電影不一樣。」當然不一樣了，我們看的那些電影中，一家人通常會被鯊魚吃掉，還會被恐龍追殺，但最終，他們總是會一起度過難關。於是兒時的我不禁想著，如果我們的威爾斯鄉下小鎮哪天被隕石襲擊，或遭到外星人入侵，那麼我的父母是不是就不會離婚了？坦白說，我當時還真的有點希望一九八九年會發生核戰呢。

二十五年後，藝術總監亞當‧斯托克豪森（Adam Stockhausen）將《間諜橋》劇本初稿寄給我時，我讀著那些文字，看到了似乎很熟悉的場景：一家人圍坐在桌邊吃早餐，吵吵鬧鬧、杯盤狼藉，但除此之外，他們一切都好。孩子們玩著機器人玩具；彼此爭吵、寫作業，母親烤了麵包，而父親正在看報紙。那是暴風雨前的寧靜。或者應該說，在這部片中，那是在孩子們的父親，一個白領階級保險律師，在冷戰中期為一個叛國的俄羅斯間諜辯護之前，一家人享受的寧靜時刻。

我和亞當之前就合作過兩部電影。製作《歡迎來到布達佩斯大飯店》時，他聘用了我和德國電影平面設計師莉莉安娜‧蘭布里夫（Liliana Lambriev），一起協助魏斯‧安德森打造電影中的祖部羅卡共和國。亞當和魏斯在德國創造出這座虛美麗的阿爾卑斯國度，而我們有幸成為首批進入這個虛構世界的人。後來，他又帶著我們回到他的團隊，開始為他正在製作的一部科幻電影設計概念圖，這部電影以一架數百年後的太空船為背景。

《間諜橋》則又是另一個完全不同的世界了。這是一個依據史實改編的故事，是真實的人物在真實歷史中發生過的事件。亞當準備打造出二十世紀中期的紐約、東西柏林、U-2偵查機、阿拉巴馬州的監獄、巴基斯坦的美軍基地，以及莫斯科的法庭。如果想讓觀眾相信電影中這些不同時間和地點的轉換，就必須仰賴大量能重現當代的平面設計，像是美式的廣告看板和旅館的霓虹標誌、蘇聯的傳單、嵌在中情局總部地板上的標誌。還有許多非常微小的圖案，很難在畫面中引起注意，比如跨國簽證、走私的鳳梨罐頭、早餐桌上的牛奶盒等等。我想起小時候看過的那些電

影，那些史匹柏所執導的動作片，主角意味深長地說道：「我們需要一艘更大的船。」而我總覺得，是那些十分貼近真實日常家庭生活的畫面首先吸引了我們。因此當我讀著《間諜橋》的劇本，我認為這是一個很棒機會，我能幫助讓這位導演，讓他打造的世界變得更加真實，就像他小時候為我們創造的世界一樣。

The Great Big Book of
WHEELS
AND WINGS

A GREAT BIG book of HUGE TRAINS, FAST
PLANES, and BIG TRUCKS (and some SMALL
ones too) perfect for VEHICLE-MAD BOYS.
From ENORMOUS heavy hauler dump trucks to
ZOOMING FIGHTER JETS, you'll discover the
BIGGEST and most POWERFUL winged and
wheeled machines EVER MADE by man.

BY ARTHUR W. BLATT, JR.
ILLUSTRATIONS BY JULIA O. HEYMANS

THE GREAT BIG BOOK C? *of* **NEW YORK CITY**
1711 PINE ST., NEW YORK, NY

大讀本出版社的的《車輪與機翼》
《間諜橋》

當湯姆‧漢克斯飾演的詹姆士決定為俄羅斯間諜辯護時,他的家也被憤怒的美國民眾盯上,他們朝著詹姆士家客廳的窗戶砸磚頭。他的兒子羅傑由當年十歲的童星諾亞‧施納普(Noah Schnapps)飾演,在那個年代,學校老師會教孩子們如何在空襲時躲起來,因此在這段戲中,導演想讓小羅傑拿著一本大大的書,高高舉過頭頂來保護自己。導演說他希望那書是小男孩都愛讀的汽車圖鑑繪本,而羅傑可以「躲」在底下。

我們於是設計了這本《車輪與機翼》,是由虛構的「大讀本出版社」所發行的精裝書,內容涵蓋了飛機、火車和汽車的圖鑑,作者則同樣是虛構的,名叫亞瑟‧W‧布拉特。上面甚至還有作者簡介,寫著:「亞瑟‧W‧布拉特和你一樣熱愛汽車,他在你這年紀就開始寫書了!現在他與妻子漢娜,以及他們的貓雷金納德一起住在紐約。」

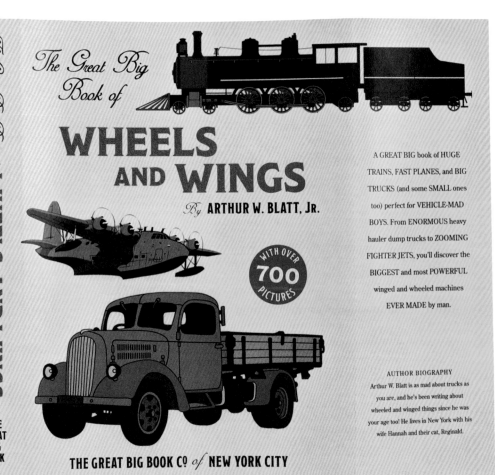

The Great Big Book of

WHEELS
AND WINGS

By **ARTHUR W. BLATT, Jr.**

WITH OVER
700
PICTURES

A GREAT BIG book of HUGE TRAINS, FAST PLANES, and BIG TRUCKS (and some SMALL ones too) perfect for VEHICLE-MAD BOYS. From ENORMOUS heavy hauler dump trucks to ZOOMING FIGHTER JETS, you'll discover the BIGGEST and most POWERFUL winged and wheeled machines EVER MADE by man.

AUTHOR BIOGRAPHY

Arthur W. Blatt is as mad about trucks as you are, and he's been writing about wheeled and winged things since he was your age too! He lives in New York with his wife Hannah and their cat, Reginald.

THE GREAT BIG BOOK C9 of **NEW YORK CITY**

西德的食品包裝
（《間諜橋》）→ →

即使在冷戰期間，柏林圍牆兩側仍會互通有無，但東德人民的行動受到限制，這也表示一般人很難取得來自西德的物品。西柏林人有時會把零食偷偷運送給他們在城市另一頭的朋友和家人，比如罐裝的蒸發奶、豌豆罐頭或整盒方糖。這些道具根據某個德國受歡迎的品牌設計，但最後沒有出現在電影的最終剪輯版本中。不過，它們還是有被裝進臨時演員的背包裡，他們扮演在雪地裡排隊一整天，想要穿越邊境的居民。

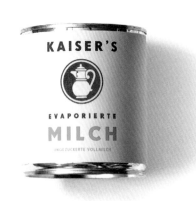

KAISER'S

EVAPORIERTE
MILCH

UNGEZUCKERTE VOLLMILCH

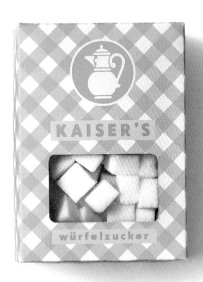

KAISER'S

würfelzucker

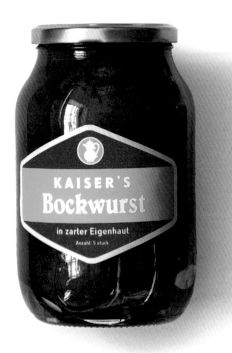

KAISER'S
Bockwurst

in zarter Eigenhaut

Anzahl: 5 stück

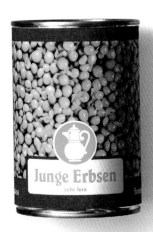

Junge Erbsen

sehr fein

牛奶盒上的文字（《間諜橋》）

這是早期的草圖，畫的是一九五〇年代布魯克林詹姆士家中的早餐牛奶盒。

IMPORTANT

This passport is NOT VALID until signed BY THE BEARER on page two. Please fill in names and addresses below.

BEARER'S ADDRESS IN THE UNITED STATES:

Name _____

Address _____

BEARER'S FOREIGN ADDRESS:

IN CASE OF DEATH OR ACCIDENT NOTIFY:

Name _____

Address _____

EXPIRATION AND RENEWAL

Unless limited to a shorter period, this passport EXPIRES three years from the date of issue shown on page two. It may be renewed for an additional period not exceeding five years from the date of issue shown on page two. The renewal fee is Five Dollars. This passport MUST be presented with your renewal application. Renewal is shown by a stamp placed in the passport.

NEW PASSPORT

When this passport expires and you want a new one, this passport should be presented with your application for the New passport.

(SEE OTHER IMPORTANT INFORMATION ON INSIDE OF BACK COVER)

IMPORTANT INFORMATION FOR YOU

- **TRAVEL IN DISTURBED AREAS**
 If you travel in disturbed areas, you should keep in touch with the nearest American diplomatic or consular office.
- **PROLONGED RESIDENCE ABROAD**
 If you make your home or reside for a prolonged period abroad, you should register at the nearest American consulate.
- **LOSS OF NATIONALITY**
 You may lose your United States nationality by being naturalized in, or by voting in the elections of a foreign state; by taking an oath or making a declaration of allegiance to a foreign state; or by serving in the armed forces or accepting employment under the government of a foreign state. If you are a naturalized citizen of the United States, you may lose citizenship by residing for 3 years in the country of your birth or former nationality, or by residing for 5 years in any other foreign state or states. For detailed information consult the nearest American diplomatic or consular office.
- **VIOLATION OF CONDITIONS OR RESTRICTIONS**
 If you use or attempt to use this passport in violation of the conditions or restrictions contained in it, you may lose the protection of the United States while you continue to reside abroad, and you may be liable for prosecution (Section 1544, Title 18, U. S. Code).
- **LOSS OR DESTRUCTION OF PASSPORT**
 If this passport is lost, stolen or destroyed, report full details *immediately* to the Passport Office, Department of State, Washington 25, D. C., or to the nearest American consulate. In an outlying possession of the United States, report to the chief executive, and to the local police authorities. In loss or destruction cases, new passports are issued only after exhaustive investigation.
- **ALTERATION OR MUTILATION OF PASSPORT**
 This passport must not be altered or mutilated in any way. You must not alter any dates; nor make any changes in your description, on the photograph, or on any other page of this passport. Alteration may make it INVALID. Only authorized officials of the United States or of foreign countries, in connection with official matters, may place stamps or make statements, notations or other additions in this passport.

U. S. GOVERNMENT PRINTING OFFICE

20

Visas

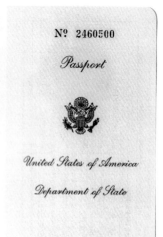

№ 2460500

Passport

United States of America

Department of State

WARNING—ALTERATION OR MUTILATION OF ENTRIES IS PROHIBITED

DESCRIPTIVE DATA

NAME	JAMES BRITT DONOVAN
BIRTH DATE	FEB. 19, 1916
BIRTHPLACE	UNITED STATES OF AMERICA
HEIGHT	5 FEET 11 INCHES
HAIR	BROWN
EYES	GRAY
VISIBLE MARKINGS	BLUE
OCCUPATION	XXX ATTORNEY
WIFE	MARY DONOVAN
CHILDREN	JAN, JOHN, MARY ELLEN
ISSUE DATE	DEC. 20 1955
SIGNATURE OF HOLDER	

THIS PASSPORT IS NOT VALID UNLESS SIGNED BY THE PERSON TO WHOM IT HAS BEEN ISSUED

Visas

19

Visas

18

Visas

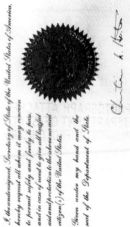

I, the undersigned, Secretary of State of the United States of America, hereby request all whom it may concern to permit safely and freely to pass, and in case of need to give all lawful aid and protection to the above named citizen(s) of the United States.

Given under my hand and the seal of the Department of State.

Photograph of bearer

4	17
6	15
8	13
10	11
12	9
14	7
16	5

Visas

PHOTOGRAPH ATTACHED
DEPARTMENT OF STATE
PASSPORT AGENCY N.Y.

護照（《間諜橋》）←

製作平面道具有時讓人感覺彷彿在偽造文書，像詹姆士的這份護照，就與一九五〇年代真實的護照一模一樣，可以拆開、掃描、加工，再重新組合起來。它也是一份主角道具，當柏林圍牆的巡警要求詹姆士出示身分證明時，這份護照得到了一個特寫鏡頭，雖然只有那麼一瞬間。

青少年雜誌內頁，一九五〇年代
（《間諜橋》）→ →

如果這組平面道具想在片中發揮作用，那麼勢必就得唬住飾演小羅傑的十歲演員諾亞・施納普。我們特地讓雜誌刊載了駭人的文章內容，模仿那個年代真實的青少年雜誌所使用的煽動語言。我們先是放了一張紐約的空拍圖，再疊加一張圖表，顯示著「五千萬噸級炸彈」的爆炸半徑，火焰將能立即摧毀曼哈頓，而強光則能影響到更遠的範圍，距離爆炸現場三十英里處，所有裸露的皮膚都會遭到三級灼傷，任何直視的人都會從此瞎掉，且幾分鐘之內，全紐約將有四百萬人喪生。就連逃過死劫的人，下場也並不樂觀，這座城市往後將成為「一片全然的荒土，僅剩無數絕望和身患絕症的倖存者在此遊蕩。」

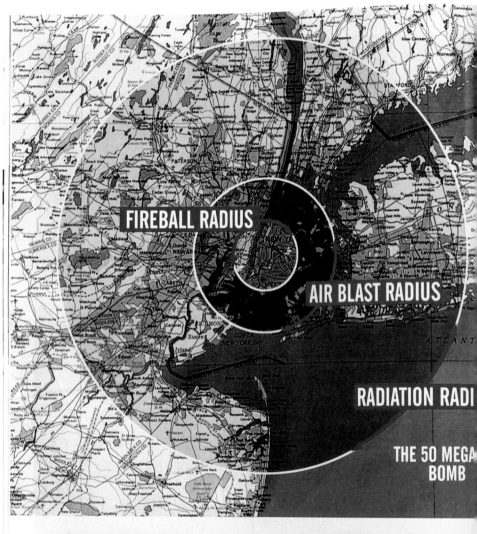

FIREBALL RADIUS

AIR BLAST RADIUS

RADIATION RADI

THE 50 MEGA
BOMB

THE BLAST RADIUS

By ARTHUR B. GORDON, Nuclear Warfare Analyst.

With the Russian advancement in both Nuclear Warfare and space patrol, "bomb" is the hot word of the year. We asked blast analyst Arthur B. Gordon from the New York Centre for Nuclear Research to give some examples of the effects of the 50 Megaton Bomb. Exactly how far can we expect the destruction to reach, and what happens in its midst?

GROUND ZERO

The 50 Megaton Bomb is one of man's deadliest inventions yet, and within split seconds of its detonation a fireball explodes in every direction, reaching as far as two miles from Ground Zero and completely enveloping Manhattan Island. Temperatures would reach unfathomable heights of 20 million degrees Farenheit, vaporising absolutely everything in its path – buildings, vehicles, trees, cars, animals and people.

2-5 MILES

At two to five miles from Ground Zero this nuclear blast would produce pressures of 25lbs per square inch, and winds in excess of 650 miles per hour. The magnitude of these extreme forces would destroy everything in seconds including reinforced steel and concrete structures. Even underground bomb shelters would be crushed by the ground blasting in overhead.

5-16 MILES

At five to sixteen miles from Ground Zero the heat would melt all glass and even vaporise car sheet metal. At this distance the blast wave would create pressures of 7-10lbs per square inch and winds of 200 miles per hour.

17 MILES

At seventeen miles from Ground Zero, so strong is the heat from the fireball that just its radiant temperature alone would ignite all easily flammable materials. Curtains, paper, leaves, clothing, and gasoline would all spontaneously combust, starting thousands of fires across the land.

17-29 MILES

At distances of seventeen to twenty-nine miles from Ground Zero, the blast would still produce pressures of albs per square inch – which is enough to shatter glass windows. Shards of glass from these windows now become deadly missiles in themselves as they shoot off at 100 miles per hour.

30 MILES

At thirty miles, the heat would be so intense that any exposed skin would suffer third degree burns from the flash of light alone.

"IF A 50 MEGATON BOMB DROPS AT THE HEART OF NEW YORK CITY, IT'S NOT JUST MANHATTAN THAT WOULD BE ANNIHILATED"

Anyone who turned to look at this sudden flash would be permanently blinded by burns on their retinas and at the back of their eyes.

100 MILES

Within a radius of 100 miles most people can expect to suffer from severe radiation sickness, beginning anywhere from half an hour to two months after the blast.

THE DEATH TOLL

Within minutes after an explosion in Manhattan, four million people across New York City would die, and more than three-quarters fatally injured. Rural and suburban New York State would suffer severe radiation sickness, and the city would become a veritable wasteland, roamed only by a few thousand desperate and terminally ill survivors.

TAKE SHELTER: *The best protection is an underground shelter with at least 3 feet of earth or sand above it.*

彈孔（《間諜橋》）

在不同的國家工作也會帶來不同的挑戰。當《間諜橋》的德籍美術指導馬可‧比特納‧羅瑟（Marco Bittner Rosser）問我「有沒有彈孔」時，我完全不明白他的意思。當時我的平面設計同事莉莉安娜立刻跳出來拯救我，說她的硬碟裡有一些可以用的素材。相較起來，柏林經常製作一些關於二戰的電影，因此大多數在當地工作的電影平面設計師們，也經常會需要製作彈孔來裝飾某一面外景牆。他們會在城市中找到一些現今仍被保留的真實彈孔拍下來，並複印在透明的醋酸纖維板材上。

我們微調了一下莉莉安娜的檔案，好讓它能更加符合這一幕會出現的特定牆面，那真是一個漫長的試色過程。但到了拍攝當天，卻出現了一個我們無能為力的問題，柏林十一月的低溫和牆上的薄霜，讓醋酸纖維不斷剝落。最後，彈孔只能在後製期間用電腦加上去。

《奇光下的秘密》美國自然史博物館的地磚

在陶德・海恩斯（Todd Haynes）執導的《奇光下的秘密》（Wonderstruck, 2017）中，有一個關鍵場景是發生在美國自然歷史博物館，展廳裡有一座「奇珍收藏櫃」，而在那無盡的抽屜和架子上，擺滿了各種珍寶，有爬蟲類標本、斷掉的頭部、乾燥的魚類、昆蟲的外骨骼和哺乳動物的糞便。不過，這整個場景由我負責的部份就只有地板而已，我先用電腦將地面繪製出來，然後在乙烯基塑料上，以墨水印製出超過一千兩百平方英尺的瓷磚地面。至於地磚上的花紋，一開始是以平面向量圖製作，接著用Photoshop為每塊瓷磚著色、製作材質，還要做出陳舊的磁磚縫，並營造紋路的天然質感。

製作足夠的磁磚數量和多變的紋理樣式也很重要，如此一來，就算廣角拍攝，也看不出紋路有任何重複的地方。不過通常在乙烯基塑料鋪設完成之後，佈景設計師（scenic artist）都還會再用油漆和釉料四處裝飾一些不同的花樣。打造這樣的地面是十分費工，而且這樣的小細節，通常也不會在定剪中獲得任何一個特寫。但無論如何，這些製作過程總能帶給我一種奇特的滿足感，讓我感覺自己創造了一段視覺的把戲，將扁平的數位圖案化為幾可亂「真」的佈景。

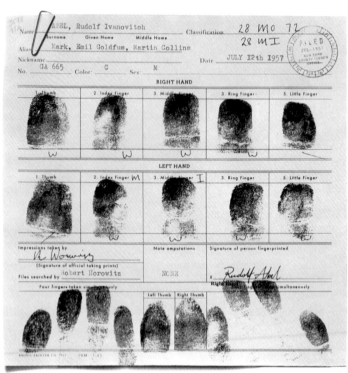

ABEL, Rudolf Ivanovitch

| Name | ABEL, | Rudolf | Ivanovitch | | Classification | 28 MO 72 |
| Surname | | Given Name | Middle Name | | | 28 MI |

Alias Mark, Emil Goldfus, Martin Collins

Nickname _____ Date JULY 12th 1957

No. GA 665 Color: C Sex: M

FILED JUL-1957 NEW YORK COUNTY CLERKS OFFICE

RIGHT HAND

1. Thumb	2. Index Finger	3. Middle Finger	3. Ring Finger	5. Little Finger

LEFT HAND

1. Thumb	2. Index Finger	3. Middle Finger	3. Ring Finger	5. Little Finger

Impressions taken by _____
(Signature of official taking prints)
Files searched by Robert Horowitz

Note amputations NONE

Signature of person fingerprinted
X Rudolf Abel

Four fingers taken simultaneously

Left Thumb Right Thumb

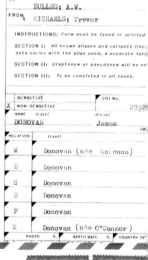

PER

TO DULLES; A.W.

FROM MICHAELS; Trevor

INSTRUCTIONS: Form must be typed or printed

SECTION I: All known aliases and variants lines
data varies with the alias used, a separate fore

SECTION II: Cryptonym or pseudonym will be er

SECTION III: To be completed in all cases.

	SENSITIVE		201 No.	
X	NON-SENSITIVE			2892
	NAME (Last)		(First)	
	DONOVAN		James	

RELATION	(Last)	
W	Donovan (née McKenna)	
D	Donovan	
S	Donovan	
D	Donovan	
F	Donovan	
M	Donovan (née O'Connor)	

| PHOTO | 4. | BIRTH DATE | 5. | COUNTRY OF |

Союз Советских Социалистических Республик

Берлин 88
Унтер-ден-Линден д 63-65
телефон 22 11 10

No. 35/360

Subject	Abel, Rudolf charged "Espionage" -	
	United States complainant.	
Location	Hotel Latham,	
	Room 339.	
Photographer	Brown.	
Taken on	7.3.57.	Eight 4 x 5 negs.

67007 6.54

LUFTPOSTLEICHTBRIEF
AEROGRAMME

15

VIA AIR MAIL
MIT LUFTPOST
PAR AVION

JAMES B. DONOVAN
484 Fuller Place
Brooklyn, 1 NY
United States of America

FORM
10-57 C.I.A

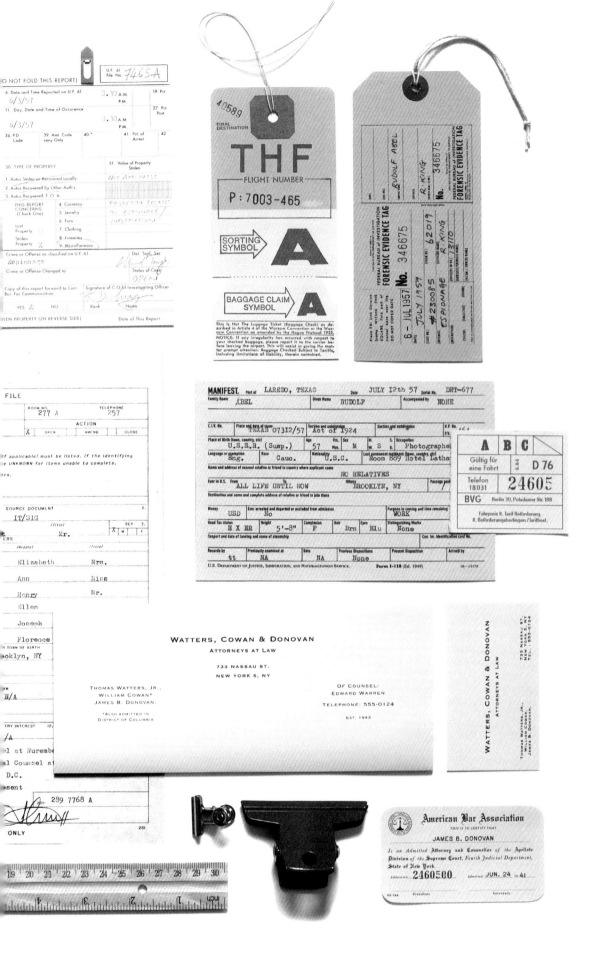

DO NOT FOLD THIS REPORT)

U.F. 61
File No. 7465A

6. Date and Time Reported on U.F. 61
3.30 A.M. P.M.
19. Pct.

6/3/57

11. Day, Date and Time of Occurrence
3.30 A.M. P.M.
27. Pct Post

6/3/57

36. P.D. Code
39. Amt. Code ceny Only
40.*
41. Pct. of Arrest
42.

50. TYPE OF PROPERTY
51. Value of Property Stolen

1. Autos Stolen or Recovered Locally
2. Autos Recovered by Other Auth's
3. Autos Recovered F.O.A

THIS REPORT CONCERNS: (Check One)
4. Currency
5. Jewelry
6. Furs

Lost Property
7. Clothing
8. Firearms

Stolen Property X
9. Miscellaneous

Crime or Offense as classified on U.F. 61
Espionage

Det. Sqd. Ser

Status of Case
OPEN

Crime or Offense Changed to

Copy of this report forward to Corr.
Bur. for Communication

Signature of C.O. of Investigating Officer

Rank
Name

YES X NO

LEN PROPERTY ON REVERSE SIDE)
Date of This Report

40589

FINAL DESTINATION

THF
FLIGHT NUMBER

P: 7003-465

SORTING SYMBOL A

BAGGAGE CLAIM SYMBOL A

This Is Not The Luggage Ticket (Baggage Check) as described in Article 4 of the Warsaw Convention or the Warsaw Convention as amended by the Hague Protocol 1955.
NOTICE: If any irregularity has occurred with respect to your checked baggage, please report it to the carrier before leaving the airport. This will assist in giving the matter prompt attention. Baggage Checked Subject to Tariffs, including limitations of liability, therein contained.

FEDERAL BUREAU of INVESTIGATION
FORENSIC EVIDENCE TAG
No. 346675

RUDOLF ABEL
R. KING
No. 346675

FEDERAL BUREAU of INVESTIGATION
FORENSIC EVIDENCE TAG
No. 346675
62019
R. KING
13110

6 - JUL 1957
JULY 1957
#230085
ESPIONAGE R. KING

FILE

ROOM NO.
277 A
TELEPHONE
257

ACTION

X OPEN AMEND CLOSE

f applicable) must be listed. If the identifying
e UNKNOWN for items unable to complete.

ers.

SOURCE DOCUMENT 2.

IT/SIG

(Title)
Mr.
SEX 3.
X M F

ERS

(middle) (Title)

Elizabeth Mrs.

Ann Miss

Henry Mr.

Ellen

Joseph

Florence

ooklyn, NY

YM

N/A

TRY INTEREST

/A

l at Nurembe

l Counsel at

D.C.

esent

289 7768 A

281

ONLY

MANIFEST. Port of LAREDO, TEXAS Date JULY 12th 57 Serial No. DRT-677

Family Name ABEL Given Name RUDOLF Accompanied by NONE

C.I.V. No. Place and date of issue TEXAS 07312/57 Section and subdivision Act of 1924 Section and subdivision U.P. No.

Place of Birth (town, country, etc) U.S.S.R. (Susp.) Age 57 Yrs. Mos. M S. Occupation Photographer

Language or exemption Eng. Race Cauc. Nationality U.S.C. Last permanent residence (town, country, etc) Room 889 Hotel Latham

Name and address of nearest relative or friend in country where applicant came NO RELATIVES

Ever in U.S. From ALL LIFE UNTIL NOW To Where BROOKLYN, NY Passage pai

Destination and name and complete address of relative or friend to join there

Money USD Ever arrested and deported or excluded from admission No Purpose in coming and time remaining WORK

Head Tax status EX ER Height 5'-8" Complexion F Hair Brn Eyes Blu Distinguishing Marks None

Seaport and date of landing and name of steamship Con. im. identification card No.

Records by tt Previously examined at NA Date NA Previous Dispositions None Present Disposition Arrived by

U.S. Department of Justice, Immigration, and Naturalization Service. Form I-118 (Ed. 1949) 16—13179

A B C

D 76

Gültig für eine Fahrt 6.66

Telefon 18031 24605

BVG Berlin 30, Potsdamer Str. 188

Fahrpreis lt. Tarif Beförderung.
lt. Beförderungsbedingen./Tarifbest.

WATTERS, COWAN & DONOVAN
ATTORNEYS AT LAW

733 NASSAU ST.
NEW YORK 5, NY

THOMAS WATTERS, JR.,
WILLIAM COWAN*
JAMES B. DONOVAN.

*ALSO ADMITTED IN
DISTRICT OF COLUMBIA

OF COUNSEL:
EDWARD WARREN

TELEPHONE: 555-0124

EST. 1943

WATTERS, COWAN & DONOVAN
ATTORNEYS AT LAW

733 NASSAU ST.
NEW YORK 5, NY
TEL. 555-0124

THOMAS WATTERS, JR.,
WILLIAM COWAN
JAMES B. DONOVAN

American Bar Association
THIS IS TO CERTIFY THAT

JAMES B. DONOVAN

Is an Admitted Attorney and Counsellor of the Appellate
Division of the Supreme Court, Fourth Judicial Department,
State of New York.

Admission 2460500 Admitted JUN. 24 19 41

HX-144 President Secretary

19 20 21 22 23 24 25 26 27 28 29 30

情報文件（《間諜橋》）←←

大多數電影平面道具都不是英雄作品，而是用作背景裝飾的紙張作品。這些文件是為《間諜橋》不同場景創作的。雖然不太會在特寫鏡頭中出現，但我們眼尖的道具管理員珊蒂·漢米爾頓（Sandy Hamilton）和搭景師蕾娜·德安哲羅（Rena DeAngelo）還是會仔細檢查每一個細節。針對

「上層紙張」，也就是整座紙堆上的第一張，我們使用了逼真且清晰的復刻文件，上面印有真實的以打字機製作的文字和圖章，並以精心挑選過的紙張印製，每個細節都為演員和觀眾創造出更加真實的電影體驗。

十八幅地圖（《犬之島》）

在魏斯・安德森執導的《犬之島》中，教室牆壁上貼有許多小地圖，描繪了日本列島十八個不同的島嶼，每座島都是以鉛筆、麥克筆、書法墨水和水彩畫繪製的。平面設計助理成川千奈美（Chinami Narikawa）和我密切合作這些作品，她負責先以鉛筆勾勒出日本島嶼的形狀，我則為島嶼畫上山脈、河流和沙灘的紋理。而我繪製道路和海灘時，千奈美就用毛筆和墨水寫上日本的地名與圖說。我們是遠端作業，我在都柏林的工作室，而千奈美在倫敦片場的美術部。她會掃描她的圖層，再以電子郵件傳給我，好讓我在Photoshop中將所有圖層合併在一起。如果你仔細觀察，就會發現，有一些島嶼的形狀是一樣的，只是經過了翻轉或旋轉，而文字等其他內容依然朝上。

U-2駕駛艙文件（《間諜橋》）←

根據一九六○年代的美國空軍歷史文件，這份清單被稱為「綠紙板」，是角色的重要裝備之一，例如U-2飛行員蓋瑞在俄羅斯上空進行監視飛行時，就會用到這份清單。「彈射座椅系統？確認沒有問題。」還有一張簡單的地圖，上面繪製出五個座標，指引著蓋瑞從巴基斯坦航行到斯堪地那維亞半島最北端的路線。但蓋瑞最後並沒有完成他的飛行，當他在穿越俄羅斯的途中被擊落，被迫跳傘著陸，並在斯維爾德洛夫斯克州附近遭到抓捕。

《怪怪箱》的箱上標籤 →

萊卡娛樂（Laika Entertainment）的定格動畫《怪怪箱》（The Boxtrolls）故事聚焦一群生活在地下的奇妙生物，他們全都身穿紙箱當作衣服。每個角色都是根據他們的「外包裝」來命名：「鞋子」就穿著舊鞋盒，「火柴」穿火柴盒，「短褲」的盒子則一直往下滑。這部喜劇華麗而充滿想像力，藝術總監引導我們創作出隨興且帶有手繪感的平面設計風格，還規定我們全片中都不能用到直線條，線條的粗細必須各有不同，繪製過程中也不能使用任何現成字體或尺規。最終的成品是動態的，經過了漫長的定格動畫製作過程，當電影終於上映時，我們也得以看見這種基本的繪製手法，成為了電影達到動感的關鍵之一。

-: TWELVE DOZEN :-

144

EGGS

MANUFACTURED by CHICKENS

FOR HEATERS

OIL

AND LAMPS

UNI-CYCLES

BI-CYCLES

TRI-CYCLES

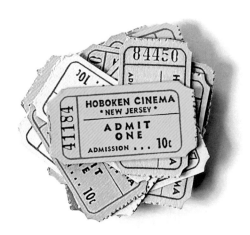

電影票（《奇光下的秘密》）

在《奇光下的秘密》中，十二歲的蘿絲保存著一本剪貼簿，裡面蒐集了所有關於她母親的剪報，她母親是一位一九二〇年代的知名演員，在她的成長過程中缺席了。除了報紙和雜誌，我們的道具管理員珊蒂．漢米爾頓還要我們在其中加入一些電影票，看起來就像蘿絲去了紐澤西霍博肯當地電影院，看了每一部她母親主演的默片。這些電影片的鮮豔色彩是根據當時真實票券設計的，但觀眾在正片中可能不會看到，因為這部電影所有一九二〇年代的場景，都是以黑白拍攝的。

《英國恐怖故事》的倫敦動物園 → →

Showtime電視網製作的哥德式恐怖系列影集《英國恐怖故事》（Penny Dreadful），雖是以維多利亞時代的倫敦為背景，但卻在愛爾蘭進行拍攝和製作，以都柏林的鵝卵石街道和殖民時期建築物代替倫敦外景，而宏偉的內景則搭設在威克洛郡的亞德摩爾製片廠（Ardmore Studios）。

第三集中，伊娃‧葛林（Eva Green）飾演的凡妮莎，與喬許‧哈奈特（Josh Hartnett）飾演的伊森，以及提摩西‧達頓（Timothy Dalton）飾演的馬爾科姆爵士，三人一起前往動物園。他們可不是一起去郊遊，而是在半夜摸黑前去尋找爵士的女兒米娜。由於劇組不可能在真正的動物園裡拍攝這些場景，除了因為其中的陳設太過現代，使用範圍也會受到諸多限制。因此，場地部門租用了都柏林的瑪萊公園，讓劇組在公園中建造許多復古的獸籠，而美術指導則與一位馴獸師合作，找來了鳥兒、猴子和幾隻狼放進籠子裡。當時有人想從英國運來一隻老虎，但某些動物福利條款規定，每隻大貓都必須和牠們的配偶一起運送過來，好讓牠們有伴。而這會讓我們的成本翻倍並超出預算，於是，最後只能以後製加入老虎的咆哮和低吼聲。

至於平面設計部門要負責的，則是設計出一系列逼真的動物園標誌來點綴公園，讓演員們錯覺每個角落都真的住著許多動物。鍛造的告示牌上，貼有手繪風格的斑馬和熊的圖案，園區地圖則細緻地繪製出充滿異國情調的鳥舍與爬蟲館。廣告看板指出，說明園區中的大象都是「訓練有素的」，還有各式各樣的大貓，總共有二十隻獅子！但這一集的最終剪輯版中，我們幾乎看不到這些作品。雖然你可能會短暫瞥見猴子館的告示，但它完全被一旁精彩的演出比下去了，在那一幕裡，凡妮莎和同行的男士們遇到了「一個瘦如柴的人，看上去是個少年，他弓著身子，正吞食著一隻死猴子」，劇本上是這麼說的。

THE SPECIES of THE
MONKEY HOUSE
OF THE ZOOLOGICAL SOCIETY of LONDON

The Monkey House was built in 1926 and re-decorated in 1878, when a modern ventilating and heating apparatus was fitted. This advanced system uses hot water to maintain a tropical climate for the Primates. Zoologists often note the monkey's close physical resemblance to man, except for the existence of a tail. It is a common perception that monkeys are covered in fleas and parasites. However, monkeys are sophisticated at grooming. They enjoy searching through another monkey's fur to nibble on a salty-tasting secretion from their neighbour's skin. They are not gorging on fleas and ticks as is the widespread misinterpretation of this activity. More robust monkeys can be seen in the Outdoor Monkey's enclosure, found next to the Paradise House. These larger species are hardier and do not require a tropical climate. Our smaller species of Primates are kept warm here.

fig. 1
SQUIRREL MONKEY
Saimiri

Nº 1
THE COMMON MACAQUE
Macaca cynomolgus

The Common Macaque is a native of India, and can be seen in almost every Zoological Garden in Europe.

Nº 2
THE VERVET MONKEY
Cercopithecus pygerythrus

Vervet Monkeys belongs to the common African genus, Cercopithecus. It is mischievous and occasionally can be dangerous to humans and smaller species of monkey. The Vervet Monkey initiates fights within his own species too. The Diana Monkey and the Mona Monkey, other species of the same genus, are very handsome and more easily trained so as to be kept as docile pets.

Nº 3
THE SQUIRREL MONKEYS
Saimiri

The Squirrel Monkeys are long limbed, elegant creatures with prehensile tails. They enjoy jumping from tree branch to tree branch and swinging from great heights.

fig. 2
THE CHIMPANZEE
Anthropithecus

Nº 4
THE CHIMPANZEE
Anthropithecus

Chimpanzees are quite intelligent, and several of them, like 'Sally' (fig. 2) who lived for many years in these Gardens, have been trained to perform tasks which show their ability to memorize and deduce problems similar to man. They show intelligence far superior to most of their species and other creatures within the Animal Kingdom. 'Sally' has lived in these Gardens for fourteen years and can quickly solve many puzzles.

Nº 5
THE CAPUCHIN
Cebus

Capuchins are very strong and easily recognisable. Most of them have a prehensile tail, which acts as a fifth limb when climbing. They also have more teeth than other species. They use these extra teeth to grind tough nuts and shells. These little monkeys are smart and well behaved.

Nº 6
THE WOOLLY MONKEYS
Lagothrix

The Woolly Monkeys are covered in a thicker fur, closer to that of wool, than other monkeys. They use their prehensile tail to swing from tree branches. Their are regularly persecuted thus their edible flesh and warm fur.

Nº 7
THE LION MARMOSET
Callitrichidæ

Marmosets are closely related to Old World Monkeys and are well known as peaceful and loving pets. Marmosets need particular care in captivity and they diet on meal worms and fresh fruit. Marmosets are found in the Monkey House where the temperature is warmer although they spend some time socialising in the Outdoor Monkey enclosure between 9 and 10 a.m. daily. They are gentle and affectionate creatures and enjoy human interaction, making great connection with the keepers and visitors to the Gardens. They have long tails, large peaceful eyes and are covered in long-haired fur.

THE GARDENS of THE
ZOOLOGICAL
SOCIETY of LONDON

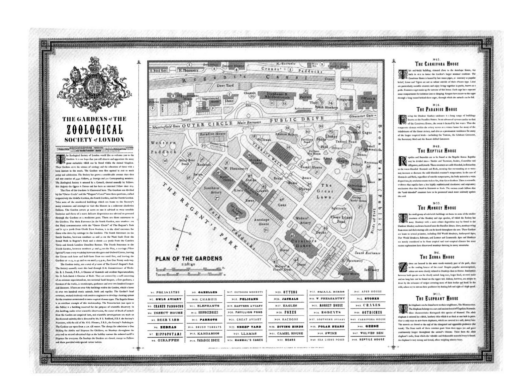

PLAN OF THE GARDENS

Nº 13
THE CARNIVORA HOUSE

Nº 16
THE PARADISE HOUSE

Nº 48
THE REPTILE HOUSE

Nº 35
THE MONKEY HOUSE

Nº 4
THE ZEBRA HOUSE

Nº 11
THE ELEPHANT HOUSE

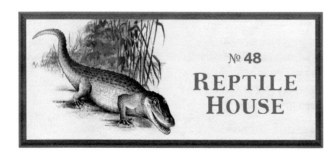

№ 48
REPTILE
HOUSE

PACHYDERMS

Elephants Rhinoceroses Tapirs

Aardvarks Wild Boars Hippopotami

ELEPHANT
HOUSE

CARNIVORA
HOUSE

MONKEY
HOUSE

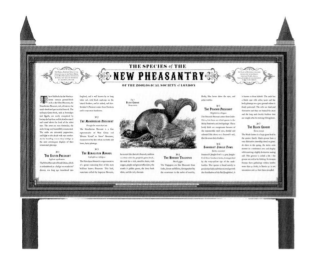

THE SPECIES OF THE
NEW PHEASANTRY
OF THE ZOOLOGICAL SOCIETY of LONDON

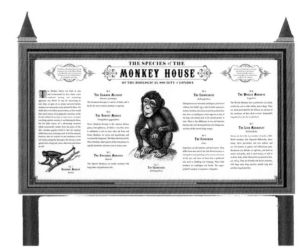

THE SPECIES OF THE
MONKEY HOUSE
OF THE ZOOLOGICAL SOCIETY of LONDON

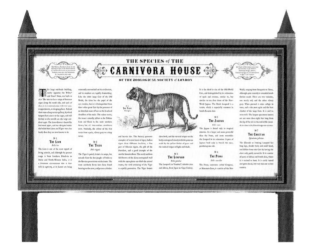

THE SPECIES OF THE
CARNIVORA HOUSE
OF THE ZOOLOGICAL SOCIETY of LONDON

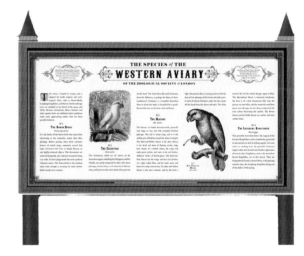

THE SPECIES OF THE
WESTERN AVIARY
OF THE ZOOLOGICAL SOCIETY of LONDON

№ 45
CARNIVORA HOUSE

№ 34
MONKEY HOUSE

№ 19
NEW AVIARY

№ 9
PEACOCK ENCLOSURE

KEEP HANDS AWAY FROM CAGE.

Please Do Not Encourage the Monkeys.

Animals Fed Daily at Noon.

PLEASE DO NOT FEED THE BIRDS.

第二章

研究

一提到過去的年代，人們便很容易想到一些泛黃的老照片，上頭有著單調的街景，幽靈般的人物各個身穿正裝，而且路上所有的招牌都是襯線字體。這當然是錯的，人們用這樣的印象複製、再複製，直到這種場景成了陳腔濫調。當我們為製作物進行研究時，過去真實的樣貌有時令人十分驚訝，有時也非常有趣。

我讀藝術學校的第一年，有位人體素描老師總告誡我們，不要過度專注於畫圖的技巧和工具，要抬頭看看眼前真實的生命。這位老師正是威爾斯風景畫家彼得‧普倫德格斯特（Peter Prendergast），而我們眼前的「真實生命」名叫珍，每到週三早上，她便會全身赤裸，為我們坐在威爾斯藝術學院那冰冷而窄小的中庭裡。人體素描對我來說並不容易。進入倫敦瑞文斯博設計學院（Ravensbourne College of Design）攻讀視覺傳達設計之前，我在一整年的基礎預科課程裡，始終都在和人體素描奮戰。比起用一根木炭來描繪完整的人體，在一張紙上排列各種字體似乎更合乎邏輯，相對來說也更容易一些。但是，彼得教我們的原則——「不要光看著紙張，要抬頭看看你周圍的世界」——在我的整個求學過程中，在我短暫的廣告生涯裡，以及在我所有的電影設計作品上，始終伴隨著我。

研究往往是電影設計的第一步。所有製作的早期階段，我們都會收集數百張參考圖片，用以當作道具和佈景的基礎。雖然我們最後會用Illustrator或Photoshop等數位工具設計製作物，但仍然需要大量理解真實物件的形式和脈絡，才能讓它們顯得真實。比如，活版印刷機和雕版印刷有何不同？印刷方法如何影響字體的風格？唯有我們仔細研究過原始物件之後，才能製作出令人信服的仿製品。

上網搜尋素材通常會徒勞無功。我們或許能在某個部落格上，找到由版主細心整理的義大利巧克力包裝紙圖案，它們如此美妙又華麗，但是，我們通常找不到任何廉價印刷的舊票根。就算找到了，這些掃描檔案的標註也不一定正確，或者日期模糊、查不出尺寸。如果到圖書館網站查看，這些用過即丟的印刷物經過了數位歸檔，也可能會產生一些誤導，像是我們從螢幕上的照片中，實在很難判斷出一張舊鈔票的大小。掃描檔案也看不出各種紙張的重量，紙質也難以確認，更無法釐清特定紙張的背面印了些什麼。十七世紀末，英國發行了黑白印刷的「白五鎊」，這就是一個很好的例子。這張紙鈔有一面是完全空白的，但是你光看掃描檔案不會知道，除非你親自拿在手裡端詳。畢竟，沒有人會掃描上傳任何空白的頁面。

因此，在真實世界中尋找古老的平面設計物，往往能取得到更好的收獲。老舊的電影票存根聯、購物收據、明信片，這些紙片或許曾在某時某地，被某個人當作臨時書籤使用，通常可以在舊書的書頁裡找到。古董商店也可能會有好幾櫃舊香煙盒庫存，甚至有些空的毒藥瓶。在都柏林，翻找祖母的閣樓是比前往古董商店更好的方法，但德國人保存這些印刷舊物的方法似乎又不太一樣。

　　製作《歡迎來到布達佩斯大飯店》初期，工作人員在德國巴貝斯柏格製片廠（Studio Babelsberg）駐點，某個週末，我和道具管理員羅賓‧米勒（Robin Miller）前往柏林一個跳蚤市場裡搜集素材。他負責找眼鏡、手錶、煙灰缸和錢包等貴重物品，而我則專門翻找垃圾，卻發覺這些碎紙才是更加珍貴的收穫！我找到了舊火車票、罐頭食品標籤、古代的陌生人的護照。在艾科納普跳蚤市場一個裝滿舊書的箱子裡，我甚至翻到更棒的寶藏，那是一本古董筆記本，某位德國女孩在裡蒐集了許多親朋好友寫的詩句和祝福語。但她為什麼要收集這些句子呢？她要搬家了？還是生病，或者瀕死？我儘量不要對這些事情過於感傷，她的日記現在是我的參考手冊，裡頭包含了二十世紀初期各種各樣的草寫字體風格。若只使用Google圖片搜尋，是不可能找到這些東西的。

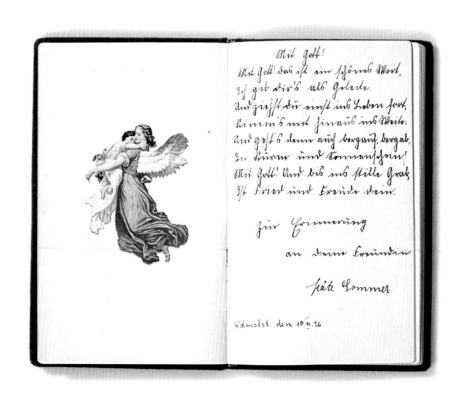

德文詩集 →→

一九二〇年代，一位德國女孩筆記本上的詩句及祝福語。

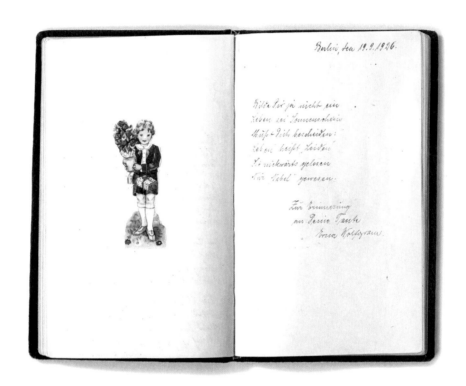

Berlin, den 19.9.1926.

Bitte sei ja nicht ein
Leben nur Sonnenschein
Mußt Dich bescheiden:
Leben heißt Leiden
So rückwärts gelesen
Für Liebel gewesen.

Zur Erinnerung
an Deine Tante
Dora Holzgراм.

Jeder rechte Streben in
einer bestimmten Rich-
tung, jede Anstrengung
sich Kenntnisse oder Fer-
tigkeiten gründlich
anzueignen, bringt
den ganzen Menschen
vorwärts.

Mit herzlichen Wün-
schen für Ihre Zukunft,
liebe Erika,

Ihr
Hch. Schindler

Harmsdorf, 14/4. 28.

Der Mensch sei niedrig oder groß,
Mißseligkeit ist aller Loos.
Nicht Gold gibt Glück, nicht Rang nicht Pracht,
Nur Lieb und Leben das Herz uns macht.

Zur freudl. Erinnerung
an
Ingeborg Marohn.

Falk den 24. VI. 1926.

各式印刷舊物 →

我們總能在千奇百怪的物品上找到古董字體設計的參考。逛逛跳蚤市場、古董商店或翻翻祖母的閣樓，可能會獲得比Google搜尋引擎上更有趣的結果。

VISULITE THEATRE
STAUNTON, VA.
ADMIT ONE CHILD
50¢ ADMISSION PRICE 50¢
031844

E.P.I. THEATRES
STAUNTON, VA.
ADMIT ONE
002108

CARTE POSTALE

CORRESPONDANCE ADRESSE

Paris le 22 Janvier 1915

HOTEL
POSADA DE LAS ALMAS
ZARAGOZA
San Pablo, 22 · tel. 226708
RESIDENCIA
SAN
BLAS
SAN BLAS
SUCURSAL DEL HOTEL POSADA DE LAS ALMAS

SHELBOURNE
HOTEL
DUBLIN

L.M.S.–N.C.C.
NAVY ARMY & AIR FORCE
ON LEAVE
THIRD CLASS
Londonderry
TO
EGLINTON
3137

L.M.S.–N.C.C.
NAVY ARMY & AIR FORCE
ON LEAVE
THIRD CLASS
Eglinton
TO
LONDONDERRY
Fare 1/-
3137

C.D.R.J.C.
THIRD CLASS
FARE 5s. 6d
Strangclar
TO
BALLYSHANNON
2913

C.D.R.J.C.
THIRD CLASS
FARE 5s. 6d
Ballyshannon
TO
STRANORLAR
2913

16

HOTEL
Atlanta
EINDHOVEN
(HOLLAND)
TEL. 3657
K 4900

ROYAL OPERA HOUSE
CAIRO

Wednesday 18th April 1945
at 9.15 p.m.

Seat in 1st Tier Box

D 9

P.T. 20 N°
FOR PERSONNEL IN UNIFORM ONLY

CARBON BISULFIDE
CARBON DISULFIDE
POISON
INTERNAL ANTIDOTE–induce vomiting with mustard
water. Then give Rochelle or Epsom Salt, Whiskey,
Brandy in water and apply heat.
EXTERNAL ANTIDOTE–First Aid for Minor Burns–
Apply Olive Oil or any cooking oil, lard or grease,
cold cream. Call physician.
CONTENTS FL. OZS. PACKED BY

GLYCERINE AND BAY RUM
with ROSE SCENTED WATER
ALCOHOL %
A lotion for the hands and after shaving.
CONTENTS FL. OZS. PACKED BY

ARSENATE OF LEAD
POISON
ANTIDOTE–Emetic of mustard, lobelia, oxide of iron and
magnesia, a cupful follow with olive oil or white of eggs.
Mucilaginous drinks sharp pains potassium bromide in water.
If mouth pain, give ice lachrymatitis paregoric in water.
Call Physician.
NET WEIGHT OZS. DISTRIBUTED BY

白五鎊的正面與背面 →

英國第一張五英鎊紙幣發行於一七九三年。這種紙幣又被暱稱為「白五鎊」，流通了近兩百年，直到一九五七年才被現代通行的五鎊紙鈔所取代。黑色墨水印製在195×120公釐（7.6×4.7英吋）的白紙上，顯得簡潔又好看。現在的五鎊鈔票尺寸是135×70公釐（1.4×2.8英吋），舊鈔比新鈔大張許多。

把這張鈔票拿在手上，你就會發現最大的設計驚喜是，它的背面沒有印刷任何東西。當你上網流覽各式紙幣掃描圖片時，你不可能會知道這一點。不過，有些搭景師還是比較傾向在電影中使用雙面印刷，因為背面全白雖然符合歷史真相，在電影畫面中卻反而會看起來「很假」。

出貨發票：織品印染廠（英國曼徹斯特，一九三六年） →→

即使是最普通的辦公室文件，也可以成為驚人而美麗的資源，幫助我們仿製出早期的文書資料。這張來自曼徹斯特一家織品印染廠的發票，展示出至少六種不同的印刷方法，更包含了工整的雕版畫，精緻描繪出工廠冒著煙的煙囪。顯然，在一九三年代的英格蘭北部，這是個值得驕傲的象徵。像這樣的作品，能為讓任何紙質道具提供寶貴的靈感，使它們看起來更加逼真，例如圖章日期、鉛筆簽名、兩種不同的鋼筆字跡和打字筆記等等，甚至紙張上打洞裝訂處，都與我們現在熟悉的尺寸不同。

下方的紅線出自蕭氏標線機（Shaw Pen Ruling Machine），這是一台大型木質與黃銅製的機器，必須由兩個人同時操作，才能「自動」在紙張上畫線，然後再裝訂成帳本和謄寫本。機器前端的橫條木板上可以安裝許多枝沾水筆，並覆蓋上一長條浸透墨水的布，當紙張通過機器時，就能畫出線條。根據不同的線條圖案設計，整個過程最多需要重複四次，才能完成全部的線條。這台機器每半小時約能印製一千張紙，比起早期用尺和紅筆手工繪製每一條線，這已經是很巨大進步。

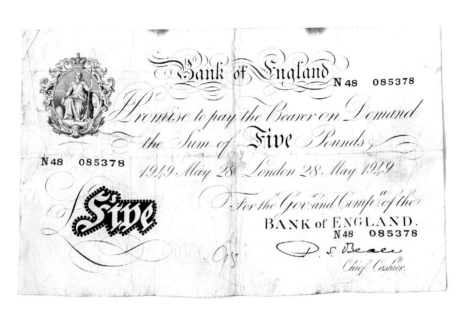

1）
「電訊暗碼位址」（telegraphic cypher address）這古老的詞，在現代聽起來反而很有科幻感。

2）
這是一種舊時的縮寫，意指「向某人某公司購買」，有時也會出現「致諸君」（意即致各位先生）等字樣。

3）
當時的公司名稱通常會含有共同創辦人的姓氏及「&」符號。

4）
大部分字體是手工書寫或平板印刷，而非採用既有字體排版，從每個字體略為不規則的間距和大小就可以分辨出來，沒有任何兩個字是完全一模一樣的。

5）
信箋設計採用細緻的銅版雕刻，有著諸多插圖與裝飾線條，當時的公司信箋多半都會描繪出公司建築物。

6）
以針具進行手工穿孔裝訂，孔洞的尺寸與我們所知的現代手持打洞工具不同。

7）
這些紅線都是由標線機印製的，這是一種大型工業設備，通常用來印製帳本和騰寫本中的線條。

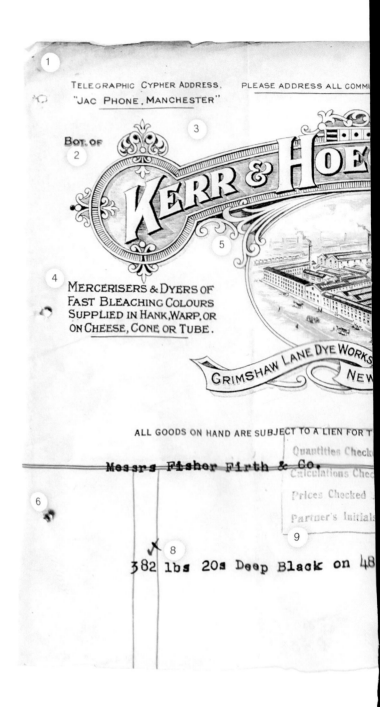

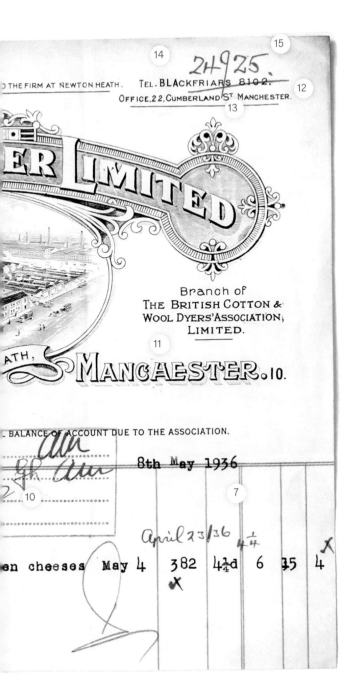

O THE FIRM AT NEWTON HEATH. TEL. BLACKFRIARS 8102.
OFFICE, 22, CUMBERLAND ST. MANCHESTER.

2H 925.

ER LIMITED

Branch of
THE BRITISH COTTON &
WOOL DYERS' ASSOCIATION,
LIMITED.

ATH, MANCHESTER. 10.

L BALANCE OF ACCOUNT DUE TO THE ASSOCIATION.

8th May 1936

April 23/36 4¼

en cheeses May 4 382 4¼d 6 15 4

15）

現在看起來，二十世紀中葉的電話號碼短得令人難以置信。

14）

注意看，「BLACKFRIARS」（黑衣修士地區）的前三個字母比其他字母稍微大一些，通常表示電話的區域代碼。

13）

「ST.」（街道）縮寫中的「T」小字位於句號的正上方，而不是句號的前面，在當時的手寫地址中十分常見。

12）

以前獨立句子結尾都會加上句號，後來逐漸取消。

11）

字體藝術家巧妙地在的「MAN-CHESTER」（曼徹斯特）中的「H」字母上，加了兩條橫槓作為修飾。

10）

藉由這兩種不同的鋼筆顏色，還有鉛筆的筆跡看來，曾有許多不同的人經手過這張發票。

9）

所有發票上都有橡皮圖章的蓋章認證。

8）

發票上的個別資訊是由打字機來標註的。

《觀察者》系列口袋書（英國，一九三七至一九六〇年）→

書籍在任何研究過程中都是不可或缺的，因為作者、編輯和編輯助理都已經分別對內文進行了一翻事實查核，相較之下，某些網路上的資訊就顯得十分隨便。在一些專門解說古董印刷物的書籍中，也會標示出這些舊物的尺寸，當你找不到某些實體的古老文件，但又必須製作出來時，這些參考書籍便十分有用。甚至書中還會標註出來源，讓你可以聯繫並取得複製許可版權。

《觀察者》系列口袋書（Observer Pocket Books）出版於一九三七年至二〇〇三年間，內容涵蓋各種主題的快速入門指南。根據這些古董書籍的流通數量和書況，現在每本價格從一元到數百元美金都有。每本口袋書的書背上，書名文字方向各有不同。現代的書背文字方向根據地區各有不同，例如，美國、英國和愛爾蘭的書背文字方向都是由上到下，德國與法國則是由下到上。英國的書背文字方向大約在二十世紀中期才形成標準化，而這些口袋書之所以方向不同，正是因為製作時間橫跨了許多年。支持由上往下閱讀的人認為，這樣當書本橫躺在桌面上時，才更容易閱讀書名。但在德國、法國和其他國家，人們認為書本垂直放在書架上時，文字由下到上比較容易看懂。無論是哪一種，當我們在製作電影書架佈景中的假書衣時，都必須要注意這些小細節。研究過程中，其實只要將真實的書籍一一拿起來端詳就好，不必太過複雜，不要盲目編造即可。

CACTI 27 WARNE

PAINTING 26 WARNE

COMMON FUNGI 19 WARNE

BIRDS EGGS WARNE

MUSIC 16 WARNE

SHIPS 15 WARNE

HORSES & PONIES 9 WARNE

DOGS WARNE

WILD ANIMALS 5 WARNE

TREES AND SHRUBS 4 WARNE

TREES 4 WARNE

WILD FLOWERS 2 WARNE

BIRDS 1 WARNE

POST OFFICE TELEGRAM

Charges to pay

_____ s. _____ d.

RECEIVED

No.

OFFICE STAMP.

PM 4 28 m Prefix. Time handed in. Office of Origin and Service Instructions. Words. m

52

From _____

T|S

352 2.25 INVERNESS 18)

To _____

MACGLASHAN AVERAGE HOTEL LANCASTER GATE LONDON-W 2 =

= SORRY MISS YOU LAST NIGHT HOPE YOURE TELLING PEOPLE

WERE ENGAGED DARLING + 2 +

For free repetition of doubtful words telephone "TELEGRAMS ENQUIRY" or call, with this form at office of delivery. Other enquiries should be accompanied by this form and, if possible. the envelope.

B or C

電報（英國，一九四一年）

我這些年來收集的素材資料夾中，混和著來自不同時間、地點的各式印刷物，而當我為不同時空背景的影視作品進行設計時，這些印刷物也是我的參考。我將它們存放在書架上的檔案盒中，用十年來當作分類，有些舊文件甚至是以世紀來分類，甚至還有一大堆待分類的相簿，我總有一天會整理！

這些印刷物中，有一些特別有趣。像是以墨水在皮紙上寫成的契約、一套彩色的紙質牛奶瓶蓋，還有我最喜歡的一件：一封一九四〇年代的電報，傳給一位住在倫敦的女士，上面寫著：「親愛的，我希望你能告訴大家我們訂婚了。」這段關係顯然不會有好結果。

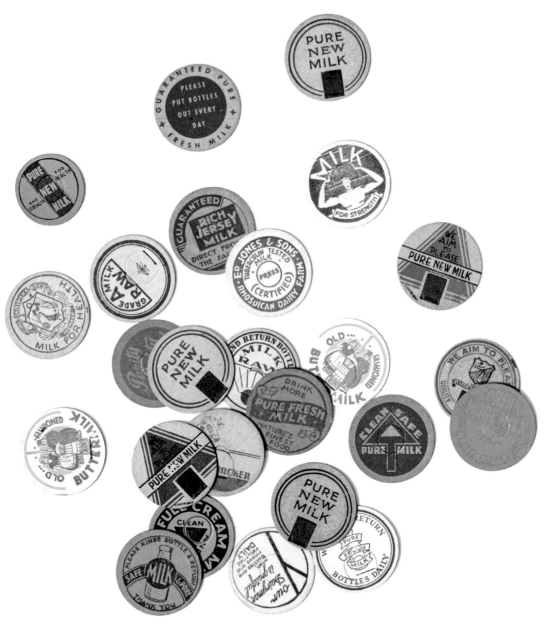

牛奶瓶蓋（英國，一九五〇年代）

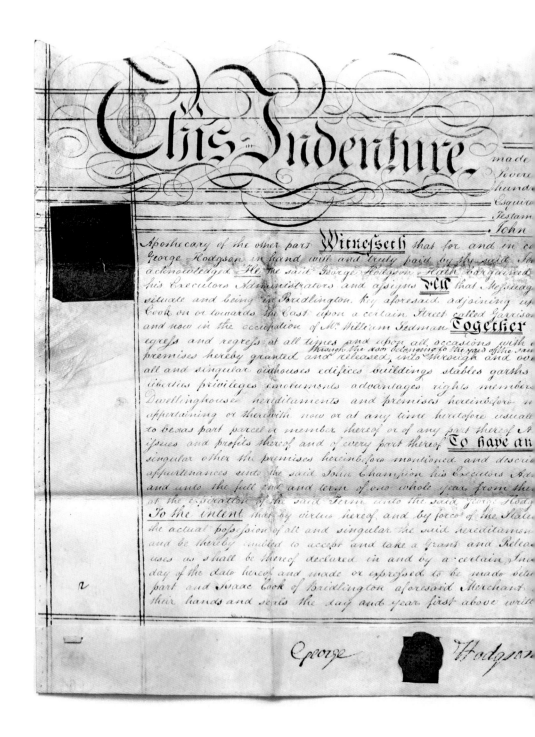

...teenth ... day of September in the Fifty third year of the reign of our
King George the third and in the year of our Lord One thousand eight ...
thirteen **Between** George Hodgson of Bridlington in the County of York ...
Son and heir at Law and also a devisee in fee named in the last Will and ...
... Hodgson late of Bridlington aforesaid Merchant deceased) of the one part and ...
... on of Bridlington Key in the Parish of Bridlington aforesaid Surgeon and ...
... on of the Sum of Five Shillings of lawful money of Great Britain to the said
... ion at or before the sealing and delivery hereof the receipt whereof is hereby
... and by these presents **Doth** bargain and sell unto the said John Champion
... or Dwellinghouse with the outbuildings yard and appurtenances thereunto belonging
... yard on or towards the North upon a Dwellinghouse house and premises of Mr John
... or towards the West and upon a Walk called the Parade on or towards the South
... use of the Well in the said open yard **And also** full and free liberty of ingress
... Horses for the owners and occupiers of the said Messuage or Dwellinghouse and
... open yard to and from the said Street called Garrison Street **Together** with
... citterns pumps pipes of Wood or Lead ways easements waters watercourses
... ments and appurtenances whatsoever to the said Messuage Tenement or ...
... and intended to be hereby bargained and sold ... belonging or in any wise ...
... cupied possessed or enjoyed or accepted reputed deemed taken or known
... version and Reversions Remainder and Remainders yearly and other rents
... the said Messuage Tenement or Dwellinghouse hereditaments and all and ...
... reby bargained and sold or intended so to be with their and every of their ...
... s and assigns from the day next before the day of the date hereof for and during
... ing and fully to be compleat and ... **Yielding and paying** therefore
... or assigns the rent of one pepper Corn if the same shall be lawfully demanded
... for transferring of uses into possession the said John Champion may be in
... mises hereby bargained and sold or intended so to be with the appurtenances
... version freehold and Inheritance thereof to him and his heirs To such ...
... Release already prepared and intended to bear date the day next after the ...
... said George Hodgson of the first part the said John Champion of the second ...
... part **In Witness** whereof the said parties to these presents have set

薇塔・薩克維爾・韋斯特小說《挑戰》的手寫稿 →

英國作家維吉尼亞・吳爾芙（Virginia Woolf）與另一位作家薇塔・薩克維爾・韋斯特（Vita Sackville-West）之間的關係有諸多記載，例如，《薇塔致吳爾芙》（The Letters of Vita Sackville-West to Virginia Woolf, 2011）一書中，就收錄了他們之間的五百多封情書，而這也成為電影《薇塔與吳爾芙》（Vita & Virginia, 2019）的原始素材。這部片由查雅・布登（Chanya Button）執導，在愛爾蘭製作與拍攝，用當地的建築物來代替兩位作家在二○至三○年代間，所居住的倫敦連棟別墅和英式豪宅。

平面設計在這部電影中勢必會有繁重的工作，因為兩位主角都在「自己的房間」寫作，吳爾芙擁有的是一間出版社辦公室，一九一七年，她與丈夫李歐納一起創辦了賀加斯出版社（Hogarth Press）。印刷原本是吳爾芙夫妻的愛好，他們在自家餐廳裡成立兩人的第一家印刷廠，吳爾芙靠著製作手工印刷書籍來分散寫作的挫折感。至一九四六年，賀加斯出版社已經發行了五百二十七本書，其中還包含了三本薇塔的書。這間出版社現在位於倫敦的塔維斯托克廣場。

這部電影大部份的室內佈景都需要成堆的信件、書籍和手稿來裝飾。我們很幸運，在為電影製作物進行研究的初期階段，便接觸到設立於紐約的朵布津女性主義典藏機構（Dobkin Family Collection of Feminism）。他們的檔案管理師幫了我們很大的忙，提供了一些薇塔的私人文件掃描檔，其中包含的小說《挑戰》（Challenge）的手寫草稿，而非交給出版社的打字初稿。

能看到這樣的手稿是非常棒的經驗，證明了研究過程是多麼寶貴，能幫助我們創造出充滿人性的作品。如果只為這個角色製作一份黑白的打字初稿，當然會讓工作變得輕鬆許多。但當我拿到薇塔的真實筆跡，看著那亮紅色立體陰影的字體，腦中不禁浮現一個上課分心的孩子，在課本隨處塗鴉。薇塔是一位才華洋溢又充滿詩意的作家，但她也經常自我懷疑，就像一個孩子一樣。這部電影讓觀眾得以看見女性作家在那個時代所面臨的挑戰，而對我來說，研究吳爾芙的生活和愛情也讓我學到了很多，不單單只是看見她最終悲慘自殺的那一段過往。

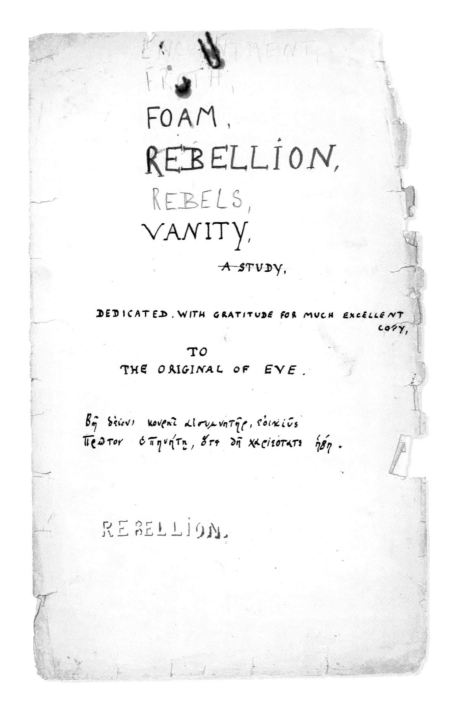

FOAM,

REBELLION,

REBELS,

VANITY,

A STUDY,

DEDICATED, WITH GRATITUDE FOR MUCH EXCELLENT
COPY,

TO

THE ORIGINAL OF EVE.

Βῆ δ᾽ ἰέναι κονέῃ ἀλουμνήτῃ, ε᾽οικῖϋς
Πρῶτον ὑπηνήτη, ὅτε δῇ χαριεστάτε ἥβη.

REBELLION.

"Stormy Weather."
Lena Horne, Bill Robinson,
Cab Calloway + his Band,
Fats Waller, the Nicholas Brothers.

With Frank Sellars of Highgate
and Stan Norman of Ealing
on 5/2/44.

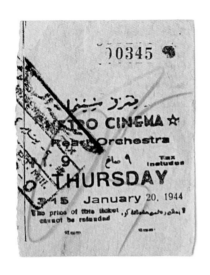
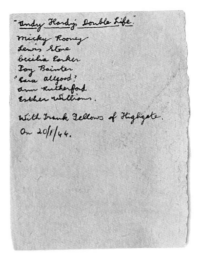

電影票（埃及開羅，一九四〇年代初）

整體看起來，我的舊物收藏一點也不美觀，更像是一堆尋常的垃圾，但可能在某些時刻成為一兩件道具的靈感。從這些一九四〇年代開羅的電影票，能看出當時票根的標準排版，上面有戲院名稱、日期、座位號碼和價格，但卻沒有電影片名。不過，這些票根的女主人已經在每張票的背面細心補上電影名稱，甚至還註記了自己是哪一天跟誰去看的。像是，「和法蘭克・費羅去看《一夫二妻》（Andy Hardy's Double Life）」，還有「和來自伊令的諾曼兄弟一起去看《暴風雪》

（Stormy Weather）」。這些舊票根讓人覺得自己手裡握有別人生活的一小部份，十分有趣，但同時，這也能幫助平面設計師們回答主管經常提出的問題：「這件道具的背面你打算怎麼設計？」電影道具的正面固然都經過精心設計，但如果一件平面道具獲得了特寫鏡頭，那多半會是在演員將它翻到背面端詳的時候。

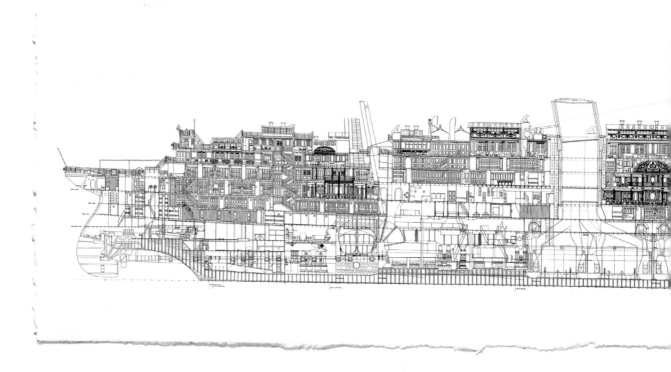

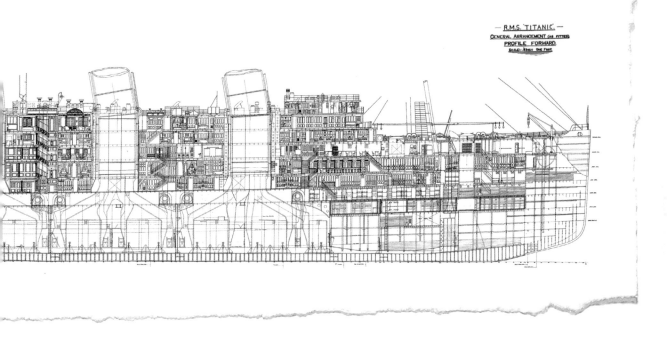

R.M.S. 'TITANIC'.
GENERAL ARRANGEMENT (AS FITTED)
PROFILE FORWARD.
SCALE:- 1/96 = ONE FOOT.

四根煙囪的鐵達尼號 ← ←

影集《鐵達尼號：血與鋼》（Titanic: Blood and Steel）以一九九〇年代的貝爾法斯特為背景，主要講述的是船隻的建造過程，而不是撞上冰山的意外。主要佈景都集中在哈蘭德與沃爾夫造船廠（Harland & Wolff）的繪圖室，而我其中一部份重要的任務，就是製作出許多船隻設計稿的半成品，交給扮演繪圖師的演員們，好讓他們看起來正在桌前專心畫圖。

在這個案子中，我們沒辦法親自從無到有畫出那麼多幅圖片。我們只有五個星期的製作時間，卻要做完一支大型設計團隊經年累月畫出的船隻設計稿，因此尋求真實設計圖的版權才是比較可行的辦法。偏偏，我們找到的版權擁有者都沒有回應我們的請求，最後我只好飛往蘇格蘭，造訪了格拉斯哥大學（University of Glasgow）圖書館，並在那裡找到盧西塔尼亞號（RMS Lusitania）的原始設計稿作為替代方案。這艘郵輪由約翰布朗造船廠製造，他們是哈蘭德與沃爾夫的競爭對手。也有人認為它是鐵達尼號的姊妹船，因為它的尺寸和命運都和鐵達尼號相似。就在鐵達尼號撞上冰山的三年之後，盧西塔尼亞號也在愛爾蘭南部海岸遭到一艘德國潛艇撞擊，當時船上共有一千兩名乘客和船員，多數人在等待救援時溺水身亡。

格拉斯哥大學的參考資料給了我們莫大的幫助，我們因此得以重新規劃，以極低的預算製作出這些船隻草圖。當我抵達圖書館時，檔案管理師已經先為我把盧西塔尼亞號的設計圖找出來，搬進一個光線昏暗的房間裡，並給了我一副白色手套，好讓我能研究這些檔案一整天。這些設計圖全都非常美麗，我們一共掃描了近二十幅來當作道具。之後，我們用電腦修掉了「盧西塔尼亞號」的字樣，再手寫上「鐵達尼號」的名字，猜想沒有人會發現。直到開拍時，片場有人用無線電呼叫我們。一位後台人員指出，鐵達尼號其實只有三根煙囪在運作，但這些草圖上，四根煙囪底部都有燃料室。一九九〇年代初期，煙囪是速度和安全的象徵，而白星航運（White Star Line）希望他們最新的遠洋郵輪具備十足的競爭力，至少表面上看起來不能輸。鐵達尼號的第四根煙囪其實是個裝飾品，它下方安裝的只是一間頭等艙吸煙室。最後，我們的藝術總監決定不追究，因為鏡頭停留在草圖上的時間實在太短，這個失誤很難真的被發現。

科幻電影的圖標 →

如果劇情設定在未來，又該如何進行研究？我曾經短暫為一部科幻電影做過設計，這部片聚焦於一艘未來兩百年後的太空船。太空船上需要各種方向標誌，以及顯示資訊的互動式面板。我的直覺反應是去研究我們現在放在口袋裡的手機，它們有著全彩的互動螢幕，這不就是一種高科技嗎？但藝術總監引導我轉向更簡單的導航標誌，像是老電影中會看到的那些象徵符號。一九七〇年代是科幻小說的黃金時代，因此，比起設計一些類似蘋果產品的圖標，觀眾對七〇年代科

幻風格的接受度想必更高。我們於是開始為太空船製作一些簡潔的導航圖示，像古老的路標一樣。但我們開始工作不久後，這部電影的資金就被抽走，所有進行中的前置作業也都停止了。另一家製片公司買走了劇本，並在美國啟用全新的演員和劇組人員來完成這部電影。

 AIRLOCK

 ARTIFICIAL GRAVITY AREA

 ARTIFICIAL GRAVITY ABSENT

 AXE

 BRIDGE

 CARGO STOWAGE

 COMM CENTRE

 COMMAND DECK

 CUSTOMER HELPLINE

 DECK Nº

 ELEVATORS

 EMERGENCY MANUALS

 FACE MASKS

 FIRE EXTINGUISHERS

 FIREWALL

 HAZARDOUS AREA

 INFOMAT

 INTERSTELLAR MESSAGING

 OBSERVATORY

 RUSSIAN LESSONS

第三章

祖部羅卡共和國

哥利茲（Görlitz）十分鄰近德國最東部的邊境，製作《歡迎來到布達佩斯大飯店》時，我們只需要走過一座小木橋，就可以去波蘭吃午餐。但我們很少這樣做，因為我們只有一個冬天的時間，就得將整座城鎮改造成魏斯·安德森虛構的「祖部羅卡共和國」，時間並不算太充裕。

《歡迎來到布達佩斯大飯店》九月下旬在柏林的巴貝斯柏格製片廠展開前置作業時，我們還不清楚哪些工作人員要和導演一起去哥利茲，哪些人要留在原地。我本以為我會待在柏林，只有攝影組和各部門的負責人會過去。當時我認為待在城市裡比較方便，可以快速取得各種製作素材。更何況，平面設計師通常不需要待在佈景旁邊。但在柏林待滿一個月之後，我們收到製作部門的通知，要整個團隊收拾行囊準備前往東部，製作期間都會待在那裡。我們所有人，包含劇組和演員，全都要前往哥利茲，將那裡當作我們整個冬天的家。

　　哥利茲在二戰期間沒有遭到炸彈攻擊，因此當地大部份美麗的裝飾藝術建築至今仍然屹立不搖。亞當‧斯托克豪森是這部電影的藝術總監，他準備將小鎮上那座宏偉但老舊的百貨公司改裝成布達佩斯大飯店的內部，我們美術部的辦公室也將設置在裡面。這真是十分特殊的工作現場，美術部門在樓上，而電影就在樓下開拍，大樓的夾層結構還讓我們可以俯視樓下的一舉一動，我們一邊在樓上製作假的指紋樣本，一邊聽著樓下傳來警匪追逐的槍聲，感覺非常奇怪，而且非常超現實。

　　祖部羅卡共和國是一個虛構的國家，這也表示我們不能像在真實國家拍攝時，參考某些真實的官方文件來製作出複製品。以前，如果要用到國旗、護照、紋章、郵票和鈔票，我們通常都會去尋找現有成品，加以翻新，或參考做出複製品。但這一次，我們從劇本得知祖部羅卡共和國的官方貨幣叫做「克魯貝克」，而我們必須憑空設計出來。

　　這種故事所需要的原創素材數量非常龐大，我一讀到腳本，就知道我不可能自己一人製作所有的平面設計。除了腳本中提及的平面道劇之外，搭景師安娜‧平諾克（Anna Pinnock）也列出了她要用於佈景的製作物清單，其中有成千上萬的辦公室文件、飯店帳本、木箱上的文字等等，這些東西不一定會在腳本中被提到，但卻是拍攝的必備裝飾。在我們的製作清單上，有將近四百種不同的物件，必須在接下來幾週之內設計並製作完成。我們顯然還需要招募另外一位助理平面設計師，也幸運地找到了莉莉安娜‧蘭布里夫，她曾在德國當地和許多個虛擬世界中，製作過各

種類型的當代電影。在哥利茲的第一天，我們和莫莉與米格爾這兩位助手，一起在五樓佈置好我們的小小平面工作室，然後開始工作。

為魏斯‧安德森的電影作設計十分令人興奮，我以前從來不曾與這樣一位充滿個人風格的導演工作，能幫助他將想法化為實物既是一種榮譽，也是一種挑戰。雖然每件道具都參考了歷史物件，但它們也都必須根據鏡頭、故事，以及他的視覺風格進行調整。他會試拍我們為他製作的每一件作品，然後讓我們修改每一個設計，直到這些道具在真實的東歐和虛構誇飾的祖布羅卡共和國之間，取得恰到好處的平衡。我們花了比其他電影更多的時間來發想每一件作品，幸好我們也有比較多準備時間，開拍前三個月我就開始準備這個案子，以前通常只有六週的籌備期，相較起來，這樣的時程安排真是一種奢侈。

寒冬裡在哥利茲這偏遠的小鎮待了一陣子之後，生活突然成為了藝術的仿擬，我們都身處在這龐大無邊的「魏式」國度裡，生活在半是想像、半是現實的世界中。劇組成員都住在一間可以俯瞰邊境河流的飯店，也就是說，我們住在德國，但從臥室的窗戶往外望，就能看到波蘭。每個清晨，我們都走路去工作，穿過一片高大的森林，來到市中心。十月中旬下起了第一場雪，十二月初，第一個耶誕市集便開放了。飯店房間沒有廚房，但還是可以自製冷肉和乳酪拼盤來吃，所以我通常會在週六早上出去買食物和雜貨，排隊結帳時，有時前面站的就是男主角雷夫‧范恩斯（Ralph Fiennes）或比爾‧莫瑞（Bill Murray），這種感覺真是奇怪。我們製作的道具和美術部門改造的建築物越多，現實和虛構之間的界線就越模糊。正式開鏡要等到一月份，而耶誕節的前幾周，我們便已經準備得非常充分，因此耶誕假期一到，我就立刻飛回愛爾蘭的家，幾乎整整一周都在睡覺，因為我知道，接下來到三月底結束拍攝之前，我們都會忙得不可開交。

布達佩斯大飯店招牌字體 →

在現代商業設計中，企業識別通常都要具備一致性，比如一家商店門口的標誌，多半會和網站上、紙袋上的標誌一模一樣，就像是平面設計套組一樣。不過，這種搭配習慣並不是一直以來都如此。二十世紀初，企業標誌的字體風格是依據材質而定，鐵門上的字體由鐵匠設計，信紙上的字體是由印刷廠選擇，這兩個工匠不太可能見過面，那就更不可能彼此交流設計風格了。

因此，當我們繪製電影中會出現的各種標誌時，我們不能採用數位複製貼上的方式製作，還期望觀眾認為這很逼真。在《歡迎來到布達佩斯大飯店》製作期間，魏斯·安德森要求我們畫了許多版本的飯店標誌草稿，依據它們在電影中設定的製作方式和製作時間，每個版本都有不同風格。像是，一九三○年代的飯店文具上，呈現的是手寫風格的雙線字體，但正門上方的招牌，因為是由黃銅製成，因此是較圓也較華麗的字體。而燈泡排列出的「H-O-T-E-L」（飯店）字樣，則又是完全不同的形狀，設計呈現弧形，以便嵌進門框裡。接著，飯店走入一九六○年代，簡潔的無襯線大寫字母排列在那共產時代的屋頂欄杆上，底部搭配塑膠材質的綠色與黃色燈箱，在遮篷上方打亮了飯店的名字。

在所有布達佩斯大飯店的招牌字體中，觀眾最熟悉的版本應該是一九三○年代屋頂上最原始的那一個，每個字母都棱角分明，且帶有鋸齒狀的襯線，看起來像是剛剛才用圓鋸切割下來的。「G-R-A-N-D」（大）中的「A」和「N」兩個字母，間距似乎有些寬鬆，但這種不規則的字距調整是刻意的，彷彿在這座建築物生命中的某個時刻，其中一個字母曾經從屋頂上鬆脫下來，某位飯店員工於是爬上梯子，試著將它黏回去。

GRAND BUDAPEST HOTEL

GRAND BUDAPEST
HOTEL

HOTEL

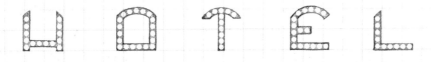

GRAND
BUDAPEST

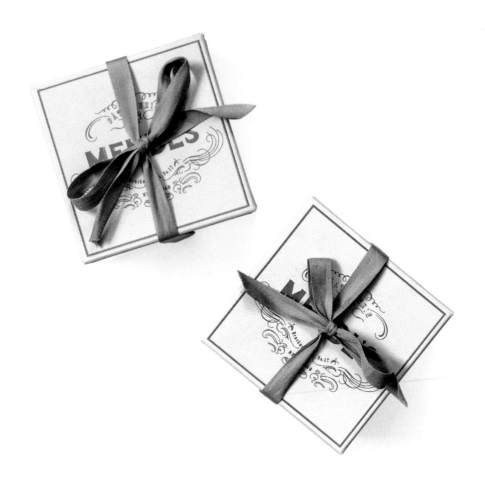

門爾德斯甜點盒

《歡迎來到布達佩斯大飯店》所有發生於一九三〇年代的故事中，幾乎每一個場景都會出現門爾德斯甜點店的粉紅色盒子。道具管理員羅賓·米勒用請柏林一家專業製盒工廠幫我們做出數百個空盒，莉莉則與絹版印刷師聯絡，讓他們用亮紅色墨水在每個盒子外面印上圖案。而所有的圖案都是手工繪製，店名「MENDL'S」（門爾德斯）由我們的插畫師負責，其餘的小字和線條則是我自己來畫。這些手繪稿都沒有經過電腦拼字檢查，而我偏偏不小心在法文字「pâtis-serie」（甜點）上多寫了一個「t」，直到拍攝進行到一半時，才被其他人注意到。在主角道具上犯了這麼明顯的失誤讓我我很慚愧，尤其是當時好幾百個盒子都已經入鏡了。後

來製作人也提出了十分務實的解決辦法，錯字會在後期製作中被修掉，至少在任何觀眾能清楚看見的盒子上。

過了幾個月，當電影上映之後，門爾德斯甜點盒的仿製品開始出現在網拍平台eBay上。其中一些和本尊非常接近，但畢竟盒子上的紅色和粉紅色都是我們特別調過的，緞帶也是特殊材質，很難仿製得完全一模一樣。無論如何，我們至少可以確定的是，電影畫面裡出現那些盒子絕對是我們親手製作的真品──因為我多寫了一個「t」。

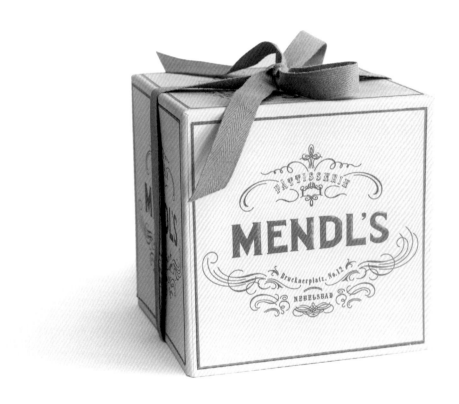

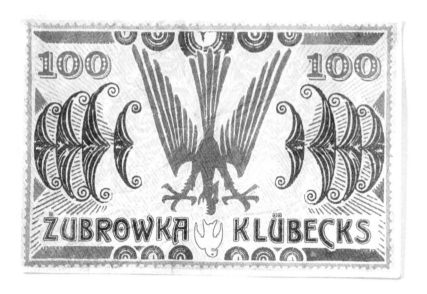

三張克魯貝克鈔票 ←

祖布羅卡共和國的國徽，也就是一隻追捕鴿子的老鷹，出現在他們國家的各種印刷物上，合法鈔票上也能看到。他們的鈔票共有三種面額，分別是十元、二十元和一百元，每一種的尺寸和顏色都不一樣。與現代真實的貨幣相比，一百克魯貝克紙鈔似乎很大張，但它們是參考了歷史上的貨幣尺寸設計的，導演引導我們去研究法郎在上世紀初期的巨大變革。

祖布羅卡共和國的郵票 →

根據劇本描述，獄中大老路德維的越獄指南是一份既簡單又極為詳細的地圖，還有城堡建築群的平面圖，飯店總管葛斯塔夫還對其中展現出的藝術性發出一番讚嘆。當我們在劇本上讀到這張圖片擄獲了主角的注意力，這就是一個非常明確的訊號，表示這張地圖可能會在電影中獲得一個特寫鏡頭，因為電影人物很少談論平面設計。

這座監獄的外景是在德國薩克森（Saxony）的克里斯坦堡（Kriebstein Castle）拍攝的，內景則在齊陶（Zittau）的一座廢棄的監獄裡。在電影製作的世界中，本就很常使用兩個不同的場地來拍攝劇中同一座建築的內外景。因此，我們要畫出路德維的地圖，就要分別研究外景團隊拍攝這兩個地點的照片，並回溯劇本中角色們的對話，對白中搭配了許多喜劇元素，同時詳細描述了監獄的結構，包含圍牆上的鐵絲網、所有的門、通風口、鐵窗，還有七十二個守衛在樓下、

十六個在塔內，他們與下方那滿是鱷魚的護城河之間，則相距三百二十五英尺高。

地圖的背面也需要設計，因為劇中的這張圖是被畫在一個信封內層。如果我們要做出信封，就需要做些信封上的標籤，標籤需要郵戳，郵戳則要搭配郵票，而一個虛構國家的郵票上，還需要一位虛構的國王。祖布羅卡共和國的國王長什麼樣子呢？雖然劇本沒有提到，但他還是必須以某種形式存在電影中。郵票上的木雕圖案是由我們的插圖畫家珍繪製的，靈感來自德國總統興登堡（Paul von Hindenburg）的一張舊照片，他蓄著大大的翹鬍子，符合史實。

獄中大老路德維的越獄地圖 →

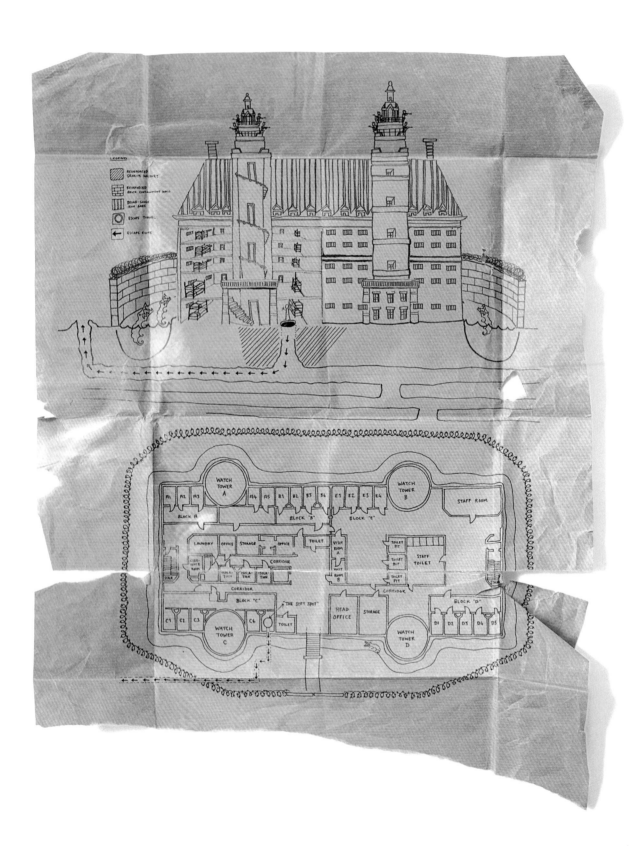

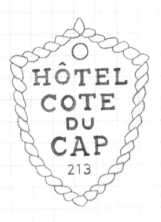

HÔTEL
COTE
DU
CAP
213

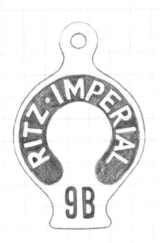

RITZ·IMPERIAL
9B

CHATEAU ✳
LUXE
24

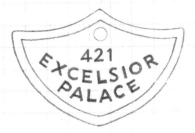

421
EXCELSIOR
PALACE

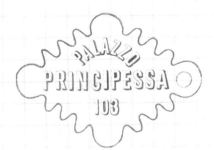

PALAZZO
PRINCIPESSA
103

鑰匙圈

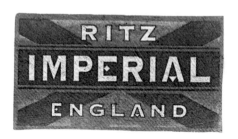

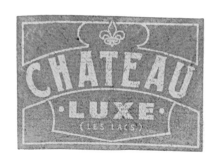

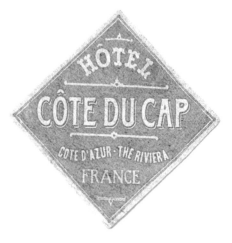

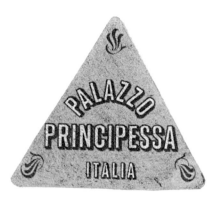

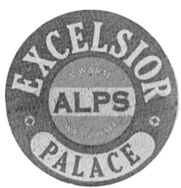

行李吊牌 ←

故事中還有另外五家飯店與布達佩斯大飯店並駕齊驅，分別是：麗思帝國、豪華城堡、卡普海岸、公主宮殿和頂級皇宮大飯店。這些飯店名稱我們一開始可以在德夫人行李箱上的貼紙看到，後來葛斯塔夫越獄時，他致電給十字鑰匙聯盟的總管們求援，每間飯店都有各自的特寫鏡頭。

一九六〇年代的餐廳菜單 →

年邁的穆斯塔法先生從餐廳菜單上選好了晚餐，而菜單本的封面上，正是那幅「蘋果少年」畫像。劇本上說這幅畫是文藝復興藝術家「約翰內斯・范・賀伊特」的作品，而事實上是導演委託一位英國肖像畫家麥可・泰勒（Michael Taylor）繪製的。製作菜單封面時，我們收到指示，不能掃描原作後列印出來，而是必須以水彩等方式重新畫出這幅作品，彷彿有位飯店老主顧特別為了紀念原作而親自重新繪製。如果要達成這種效果，比起請美術部門的同事刻意偽造某一種畫風，我認為直接找劇組以外的人來畫可能會更好。因此，為了忠實呈現出原創精神，我在有限的時間裡，我打電話給一位很適合的人選，並靠著她的幫助來完成我的使命——遠在北威爾斯史諾多尼亞老家中，我那七十歲的母親瑪麗。

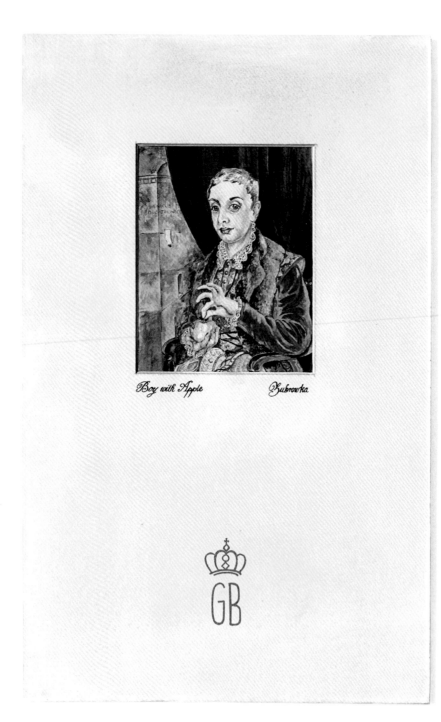

Boy with Apple *Zubrowka.*

GB

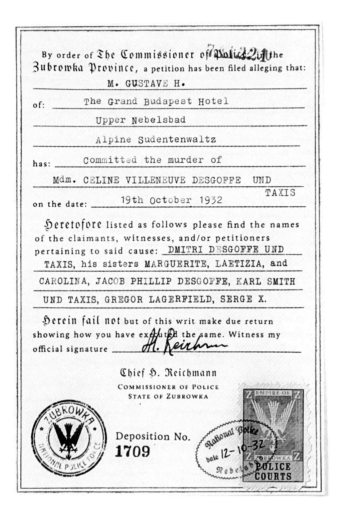

By order of The Commissioner of Police in the Zubrowka Province, a petition has been filed alleging that:

M. GUSTAVE H.

of: The Grand Budapest Hotel

Upper Nebelsbad

Alpine Sudentenwaltz

has: Committed the murder of

Mdm. CELINE VILLENEUVE DESGOFFE UND TAXIS

on the date: 19th October 1932

Heretofore listed as follows please find the names of the claimants, witnesses, and/or petitioners pertaining to said cause: DMITRI DESGOFFE UND TAXIS, his sisters MARGUERITE, LAETIZIA, and CAROLINA, JACOB PHILLIP DESGOFFE, KARL SMITH UND TAXIS, GREGOR LAGERFIELD, SERGE X.

Herein fail not but of this writ make due return showing how you have executed the same. Witness my official signature

Chief H. Reichmann
COMMISSIONER OF POLICE
STATE OF ZUBROWKA

Deposition No.
1709

葛斯塔夫的書面證詞

我們製作初期還待在柏林的時候,道具組租了一台一九三〇年代的打字機,讓我用來製作一些樣張。這台鑄鐵機器十分巨大沉重,是原裝的德國愛德勒打字機,至今依舊能順暢運作,而我們敲擊鍵盤時所發出的噪音足以干擾整個美術部門。我們本來只租一周,但它最終還是和我們一起搬到了哥利茲,因為我們發現,幾乎所有的祖部羅卡共和國官方文件都需要用到它。電腦上的打字機字體無論如何都做成像真的一樣。

This is the last Will and Testament that I, Madame
Celine Villeneuve Desgoffe und Taxis

a resident and citizen of Lutz, Zubrowka, being of sound mind and disposing memory, do hereby make, publish and declare this document to be my last will and testament hereby revoking any and all wills and codicils by me at any time heretofore made.

I. I anticipate that included as a part of my property and estate at the time of my death will be tangible personal property of various kinds, characters and realms, including jewels and other items accumulated by me during my life.

II. I hereby specifically command my son, Dmitri Desgoffe und Taxis, Desgoffe und Taxis, herein appointed, shall have complete freedom and discretion as to disposal of any and all such property so long as he shall act in good faith and in the best interest of my estate and my beneficiaries, and his discretion so exercised shall not be subject to question by anyone whomsoever with special allowances for his
sisters Marguerite, Laetizia, and Carolina.

III. I hereby expressly authorise my Executor and my Trustee, respectively and successively, to permit any beneficiary of any, and all trusts created hereunder to enjoy in specie the use or benefit of any jewellery, chattels, or other tangible personal property (exclusive of choses in action cash, stocks, bonds or other securities) which either my Executor or my Trustees may receive in kind and any Executor and my Trustees shall not be liable for any consumption, damage, injury

to or loss of any tangible property so used, nor shall the beneficiaries of any trusts hereunder as their executors of administrators be liable for any consumption, damage, injury to or loss of any tangible personal property so used.

IV. If I am the owner of any property at the time of my death I instruct and empower only Executor and my Trustee (as the case may be) to hold such real estate for investment as to sell some or any portion thereof as my Executor or only Trustee (as the case may be) shall in his sole judgement determine to be for the best interest of my estate and the beneficiaries thereof.

V. After payment of all debts, expenses and taxes as directed under Item 9 hereof I give devise and bequeath all the rest residue and remainder of my estate including all lapsed legacies and devises and any property over which I have a power of appointment.

VI. If my estate is the beneficiary of any life insurance on any life at the time of my death, I direct that the proceeds then from will be used by my Executor in payment of the debts, expenses and taxes listed in Item 9 of this will, to the extent deemed advisable by the Executor. All such proceeds not so used are to be used by my Executor for the proper of satisfying the devises and bequests contained in Item IV herein.

Mdm. C.V.D. u. T.

VII. If any — listed in Item 9 of this will — y of any life insurance on any

92

GRAND BUDAPEST
HOTEL

UPPER NEBELSBAD, ALPINE SUDETENWALTZ
ZUBROWKA
TELEGRAM ADDRESS:
GRANDBUDAPEST (NEBELSBAD)
TELEPHONE:
NEBELSBAD 43

For my dearest Gustave

With love,

Madame D.

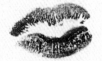

德夫人的遺囑，以及她給葛斯塔夫的紙條 ← ←

根據劇本的描述，德夫人的遺囑是在她丈夫去世之前起草
的，撰寫時間大約在一八八六年。我們於是使用了一種柔軟
的手工和紙，能輕易做出邊緣破損及茶漬等老化的效果。我
們用沾水筆和棕褐色墨水寫上了草書，讓它看起來像是已有
四十六年的歷史。而她給葛斯塔夫的臨別紙條底部，唇印與
她在劇中的粉紅色唇膏一模一樣，我們特地從蒂妲·絲雲頓
（Tilda Swinton）的化妝師那裡借來她的口紅。

情詩集，第一卷 →

季諾寫給阿格莎的浪漫情詩並沒有以特寫鏡頭的方式呈現在
電影中，而是被當作字卡來使用。我們第一次試寫的筆跡太
過正式，看起來就像是手寫藝術家精心撰寫的，其實確實如
此。導演於是建議我們教飾演季諾的東尼·雷佛羅里（Tony
Revolori）怎麼使用沾水筆，讓他直接臨摹藝術家寫好的版
本，但不能用尺或描圖紙，這樣寫出來才會更自然。最終的
成品看起來真的像是他的角色所寫，我們再將這些字複製到
詩集中，小心地保存所有的捲曲和翹起的地方。

For my dearest darling
treasured cherished
Agatha
whom I worship
With respect, adoration,
admiration, Kisses, gratitude,
best wishes
and love From

Z to A

J. G. Jopling, Esq.
PRIVATE INQUIRY AGENT

殺手喬普林的名片

喬普林的名片以黑色單色凸版印刷製成，文字置中，字級也較小。我們參考了一九三〇年代真實的名片排版，這些名片全都不會放上聯絡資訊。它們又被稱為「拜訪卡」，是造訪熟人朋友和家庭時的社交工具，通常是上流社會才會這麼做。當僕人前來應開時，你要先將卡片遞給方，而他則會將卡片放在銀色托盤上，然後端回屋裡給你要找的人。如果對方在家，他們便會下樓來招呼你。如果他們在家但不想接待訪客，他們會拿出一張自己的卡片放在托盤上，要僕人端給你。而要是他們在家，但既不想接待訪客，更不希望你再度前去拜訪，他們就會將自己的卡片裝在一個信封裡，然後要僕人拿給你，這是一種暗號，但當時的人普遍都能解讀。

½ kl-. Friday, October 19th, 1932 nr. 314

Trans~Alpine Yodel

Morning Edition

Weather: East and northeast 10 to 20 m/s, strongest by the southeast coast. Some snow-showers in the southeast and east. Frost 0 to 12 degrees C, coldest inland in the north. North-east 8 to 18 m/s, strongest wind in the southeast. Snowshowers in the north and east, but fair weather in the southwest. Frost widely 0 to 5 deg. Stiff northeast wind. Snowshowers in the north and east, but snow in the east in the evening. Fair weather in the southwest. Similar temperature. Northeasterly wind and widely some snow or snowshowers, especially in the north, but rain or drizzle by the east coast. Temperature widely 0 to 5 deg.

Announcements for interests of all kinds are written by the administrators of the Zubrowkian common/general Trans Alpine Yodel newspaper, including politics, business, farming, bathing, and winter sports. Column millimeters in the advertising sections = 45mm wide, news sections 90mm wide, sports sections 90mm wide. Paper printed on 10g newsprint from Lyuzped in Zubromka. Inserts for single-weights of 20g to 30g to 40g (maximum). For special editions and special topics, readers may submit their enquiries to our archivist at the State Library in Lutz. Apply in writing.

All the news from across the nation in two daily editions

RGN 2436 Zubrowka DL 254

WILL THERE BE WAR?
Tanks at Border

The highest ranking official uner the auspices of the Chancellor Principal Friday resigned from his post under protest due to the mishandling of the Parradine Case. "I can no longer permit myself to be associated..." he murmured to the assembled tribunal before sort of trailing off. Later that afternoon, he was sighted in Krakauer Park sitting on a bench next to a blind old man. A reporter approached him tentatively and found him agreeable to a few words.

Q: What are your plans?

A: My retirement begins today. Frankly, it will be a great relief to me to unburden myself of the pressures of political life and the military establishment. I intend to travel without portfolio. Who knows where my wanderings may lead me.

Q: What of your family? Do they support your decision?

A: I did not inquire of them their opinions. They don't know one damn thing about it. Best

Talk of war remains general all along the border-counties and deep across the West Zubrowkian frontier. Those in doubt about the gravity of the situation woke up to sobering news this morning. The Barracuda Brigades of General von Schilling's iron tank division moved briskly into position above the good King's hunting grounds and trained their turret-sights on Lutz.

Silence from both the emperor and the parliamentary administration increased anxiety amongst the populace. Only the unpredictable mayor of Lutz, Mr. Barishnokov, spoke out in his own puzzling manner: "There will be no war. The men in charge know full well any escalation at this point can only mean mutual destruction, and believe you me, nobody wants everybody to lose, to win – namely themselves. It just doesn't add up.

sibility of long-term peace.

War technology continues to evolve at a brisk pace, while philosophy and theology remain at a general stand-still. Hope is fading, replaced by the blunt ideologies of today's vanguard and their firm, misguided beliefs.

Why do we fight? This question has been on people's lips consistently all through the season. Some cling to their belief in a "noble savage" but more and more the cognoscenti have been forced to admit it: it does not look good. The development of a highly enlightened intellectual mittel-Europa limned with the glow of artistic abundance, soaring with the greatest music, architecture, literature, poetry, and scientific advance in the history of human-kind -- has lead us directly down the path of self-destruction and blackest evil. There can be no satisfactory expla-

Order from Rathaus: Stop Traffic

Challenging weather conditions during the past weeks have lead to the necessity of the strict enforcement of a long-standing ban on horse-cart travel in the back-streets of Upper Lutz.

On the law books for the past fifty-odd years, the regulation was nevertheless little-known and rarely called upon. However, in part due to aging cobblestones, and especially due to slick black-ice left over from the early frost, the new policy been in full effect last week brought dozens of unwitting violators down to the Rathaus where they paid fines and argued for clemency. "Be warned," was the message from the Burger Meister. Challenging weather conditions during the past weeks have lead to the necessity of the strict enforcement of a long-standing ban on horse-cart travel in the back-streets of Upper Lutz.

Avalanche in Brauenershotten

An avalanche in the north-western region of Zubrow-

當地報紙《橫貫高山之歌》

當季諾前去書報亭採買每天要派發給房客的報紙時，畫面的左右兩邊各有一張醒目的海報，它們都有著明亮的底色，上面的雕版印刷字體則斗大寫著二十世紀初的頭條新聞標題。

至於《橫貫高山之歌》則是祖部羅卡共和國的報紙，裡頭報導了全國各地的新聞，每天發行兩次。

ZUBROWKA'S PAPER OF RECORD

Trans-Alpine
MORNING EDITION
Yodel

宣傳海報

TWO DAILY EDITIONS

Trans-Alpine
MORNING EDITION Yodel

警方文件 →

在我們一開始製作這份警方的報告時，律師柯瓦茲的六個指紋其實是來自一份一九三〇年代真實的警方文件，但隨著劇情發展，指紋慢慢變成了更具喜劇效果的道具，因為柯瓦茲被門夾到了，一下子失去四根手指。最後這個版本中的指紋看起來可能有點大，但它們是真實的尺寸——來自傑夫·高布倫的手指。

Police Report

N° 36652 A

Date 23 OCTOBER A H

Compiled by

MURDER

1. Victim DEPUTY KOVACS	2. Nature of Incident MURDER	3. Place of Incident KUNSTMUSEUM LUTZ
5. Time 7.15	UNKNOWN	6. Other cases NONE

Severe contusions to head and chest.
Excessive loss of blood. Severing of
all fingers on right hand. Fingers them-
selves not yet located and believed to
have been deliberately removed (possibly by
killer). Very little indication of struggle.
Wrongful death. Body discovered in Egyptian
wing deep storage vault, Kunstmuseum
archives. Immediately transferred to Lutz
morgue for full autopsy.

LEFT HAND

 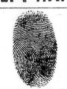 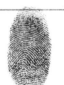 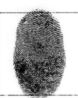

RIGHT HAND

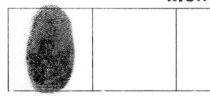

布達佩斯大飯店同名書籍 →

布達佩斯大飯店的粉紅色同名書籍是我最喜歡的道具,其中
一部份原因是,很少有人能在道具上畫出電影的片名,另一
個原因則是,這件道具在電影的開頭和結尾都扮演著重要角
色。電影一開始,戴著貝雷帽的女孩將這本書帶到盧茨墓園
向作者致敬,而在故事的最後,她坐在長凳上讀完了最後一
個章節。這兩個場景是在同一天拍攝的,那是三月底一個灰
濛濛的星期六,也是我們在哥利茲的最後一天。我們本該打
掃辦公室,將工具都收拾好,把所有東西分類放入盒中,但
大家放棄了這項任務,反而一起前去片場,一起看電影的最
後一幕,聽導演喊殺青。

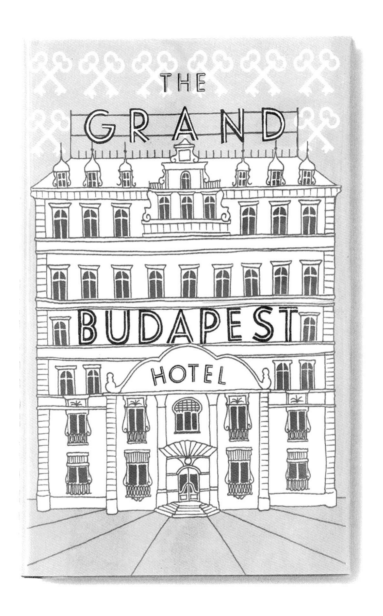

第四章

連戲

連戲是電影製作過程中的一大要點,但可能也是最乏味的部份之一,
工作人員必須將拍攝每一分鐘的細節都詳盡地記錄下來。在真正出
問題之前,這些工作非常枯燥,也因此,偶爾不連戲,便成為電影工
作中最有趣的突發事件。

我就讀電影學校時，曾經看過一個電影片段，是一對男女夜裡坐在沙漠中的帳篷外聊天。我不記得他們的對話內容，也不記得片名。如果不知道前後的劇情，這一幕基本上非常普通。後來老師要求我們再看一遍，這次要將注意力集中在道具而非對話上。我們發現，在某幾個鏡頭中，男人正在吃蘋果，但畫面從女人切換回來之後，他手裡變成了一顆梨子。在接下來的談話過程中，他手裡一下子是蘋果，一下子又是梨子，大概換了五次，但兩個角色對此都沒有任何特殊反應。看到了這個失誤之後，就很難再遺忘它了，本來稀鬆平常的角色對話，現在看起來變得十分荒謬。我記得自己對此感到非常困惑，這樣明顯的錯誤怎麼會沒有被揪出來？導演怎麼沒看到？美術部門呢？還有場記（script supervisor）呢？又或者，演員怎麼可能前一分鐘拿起梨子，下一分鐘換成蘋果，卻完全沒發覺自己吃錯了道具？

現在，經過多年來犯下各種不連戲的失誤之後，我終於明白了。這種錯誤有無數可能的成因，但最合乎常理的解釋之一，就是因為經過重拍。可以想像，殺青後的幾個月，導演在剪輯室裡看了某個場景，對某一段對話很不滿意，最後決定帶著劇組人員到沙漠再拍一次，這當然不是輕率的決定。事隔已久，連戲表上只寫了演員在吃水果。而這位演員在扮演這個角色之後，可能又已經吃過了百百種水果，連他都不記得自己拿的應該是蘋果，而不是梨子。拍完後，導演回到剪輯室，對某些重拍的對白很滿意，但也想保留其中一部份原來的畫面。他確實知道眼前有一顆穿幫的梨子，但重要的是表演品質，而不是演員手裡的道具。多年後，當二十多位電影系學生初次觀賞這個片段時，沒有人注意到這一點，證明了他的選擇是正確的。

所謂的連戲，也就是「維持連貫的戲劇細節」，這在電影製作過程中是很重要的一部份，但也可能是最無趣的工作之一。在場記的監督之下，所有的佈景、道具和角色的動作都會有詳盡的記錄。例如，演員是在第一句對白之前，還是之後抽了一口菸？她又是什麼時候把煙吐出來的？菸盒有在畫面裡嗎？她抽什麼牌子的菸？她熄掉菸的時候，這支香菸剩下多長？一直到真正出問題之前，這些細節都很枯燥。如果觀眾沒有被電影的魅力震懾住，連戲的失誤就會突然成為整部電影最受矚目的細節之一。

身為美術部門的成員，從我們讀到腳本的那一刻起，我們就有責任要在開拍前讓道具得以連戲。平面設計師接到任何案子的第一件事，就是從抵達工作室的那一刻開始，便捧著紙本腳本開始認真研究。我們會用螢光筆標示出所有道具、佈景或服裝，這些都可能是平面設計團隊的職責。有時候我們要負責的製作物很明顯，像是一張地圖或一份菜單，但也有時候不會這麼簡單。如果我們讀到某個角色掏出手帕為另一個角色擦眼淚，我們就必須問那條手帕需不需要特殊圖案。如果需要，那應該由平面設計部門負責，還是服裝部門？不同部門之間，有時會出現一些灰色地帶，這時候就會被特別標記成待解決疑問。最好的做法就是先將所有可能性都羅列出來，才不會等到搭景師對著你發怒時，才回頭去尋找某件你根本不記得自己讀過的東西。

我們也要在腳本中，標示出任何對道具設計可能有幫助的名稱或句子，它們經常隱藏在對話之中。例如，在《怪怪箱》中，蛋頭問溫妮要去哪裡才能找到紅帽組織。她說他們就在「乳酪橋」下，並指著頭頂上「牛奶街」的路牌，嘲諷地說：「往這走，牛奶會變成乳酪！」平面設計師很有可能會忽略這樣的對話，我有位道具管理員前同事，就曾難過地搖著頭說：「美術部門的人都不讀對白的。」的確，腳本對我們來說更像是源源不絕的工作指南，而不是一個故事，我們經常只讀跟我們有關的部份。舉例來說，當我看到場景標題寫著「辦公室」時，就會立刻停下來，在這樣的橋段中，我很擅長找出任何相關的製作建議，包含佈告欄、書架或桌子上堆滿的無數文件。此外，性愛場景通常可以跳過不看。因為在激情場面中，沒有人會突然拿出一張報紙，或者開始看起地圖來。

四十九張票券

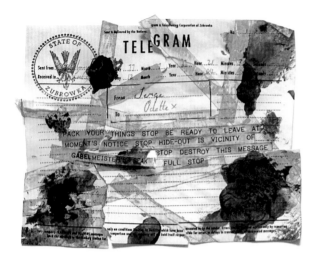

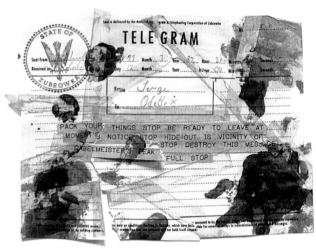

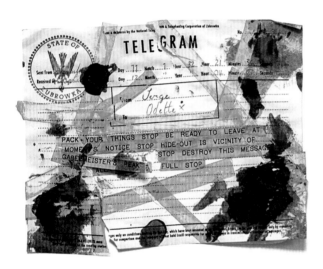

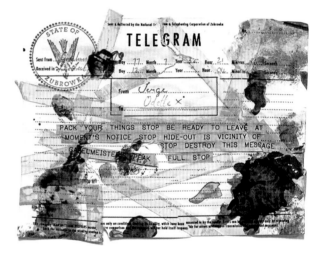

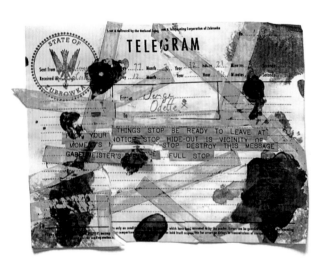

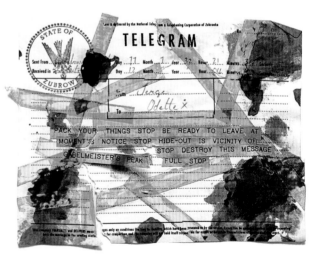

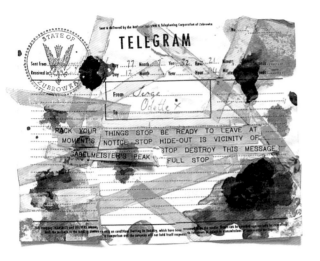

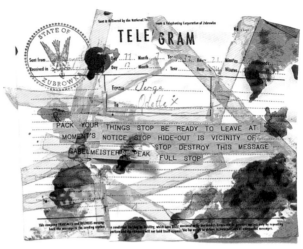

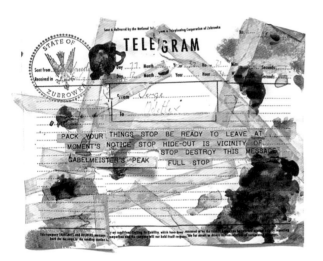

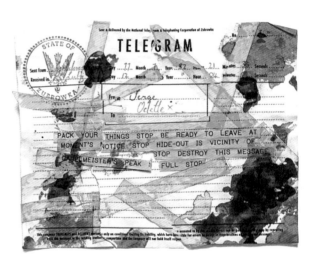

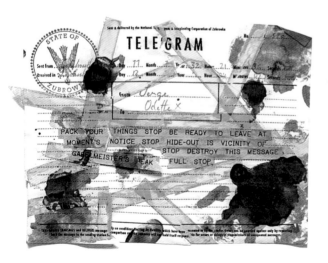

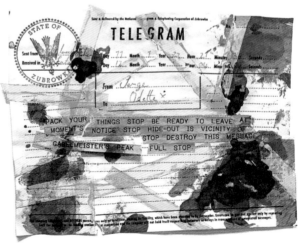

113

十二份黃色電報（《歡迎來到布達佩斯大飯店》） ←←

由於平面道具大部份是紙張製成，它們往往十分脆弱。電影佈景是一個黑暗又忙碌的地方，燭檯等其他材質的道具可以清潔乾淨，但要是有人把咖啡潑到你做好的電報上，一切都完了。為了避免拍攝過程中出現任何問題，我們會為特定的紙質道具製作額外製作一些相同的備份，稱之為「複本」。

製作一模一樣的複本是很費工的，因此我們會盡量運用各種技巧來加快製程。像是，如果我們要撕毀十二張地圖，那麼

最簡單的方法，就是將所有的地圖疊在一起，然後一次撕掉。如果有個道具要像這份黃色電報一樣，歷經一番風霜，那麼我們就會把自己變成一條小型生產線，分工合作折磨這件物品：有人負責撕毀、有人負責踩爛、有人負責重新黏合，另一個人則負責塗上血跡。

殺青後碎紙機裡的彩色腳本 →

在電影行規中，編劇們通常以十二級的「Courier New」字體來輸入腳本，而編劇軟體則會自動格式化行距。「Courier New」字體的每一個字母都等寬，無論是「I」或是「W」，在水平線上都佔據了一樣的空間。使用這樣的字母輸出，一頁腳本就會大約等於一分鐘的電影時間。編劇們因而可以估算出，一部一百二十頁的腳本，相當於一部兩小時的電影。的確有些場景以文字描述會比影像更冗長，也有時候相反，但神奇的是，不知道為什麼最終兩者通常都相等。

新手常會不小心在腳本上描寫太多細節，因此隨著拍攝的進展，編劇們便會開始依照製作部門的指示做出一些改變，並提供劇組修改過的新版本，像是：「用藍色腳本的第五至七頁，取代白色腳本的第五到十頁。」每一批修改的稿件都會用不同顏色的紙張印出來，並依照嚴格的順序釋出。最初且未經修改的是白色，再來是藍色、黃色、粉色、綠色、金菊色——我很喜歡這個浪漫的名稱，雖然有點不必要，它其實只是廉價的橙色影印紙。接著是杏黃、鮭魚紅、櫻桃紅，最後又回到藍色。紙張顏色的名稱也會印在頁面上，以防它們有時候會被影印在白色的紙張上，造成一番混亂。這可能看起來可能很誇張，但「所有人步調一致」是非常重要的。電影拍攝過程的混亂程度，可以從工作人員們手裡的腳本來判

斷，如果紙張大部份仍是白色的，那表示情況可能相對單純，但如果整份腳本被抽換得五顏六色，那就表示十分複雜了。

我們通常不會腳本的紙張上做筆記，因為它們很有可能被仍進碎紙機。我們會在所謂的「腳本拆解表」中寫下所有的資訊，基本上這就是一份詳細的筆記表格，內容涵蓋與我們部門相關的所有工作。平面設計部門的表格可能需要至少一週才能寫完，我們會仔細檢查一切，包括一定要連戲的地方。比方說，如果我們在腳本上標記了一個特定的橋段，上面寫著某個角色被要求出示身分文件，那麼我們就得假設，這個角色的護照可能已經在前面的鏡頭中出現過了。甚至，他在之後的場景中也會用到它，可能是當他在出發前收拾行李的時候？更複雜的是，這些零碎的場景可能不會依照故事順序拍攝，因此，就算這段出示護照的情節還沒有開拍，道具管理員也會先來向我們索取這本護照。更何況，在助理導演公告初步拍攝時間表之前，我們根本不知道拍攝的順序，即使有了時間表，還是有可能隨時出現異動。

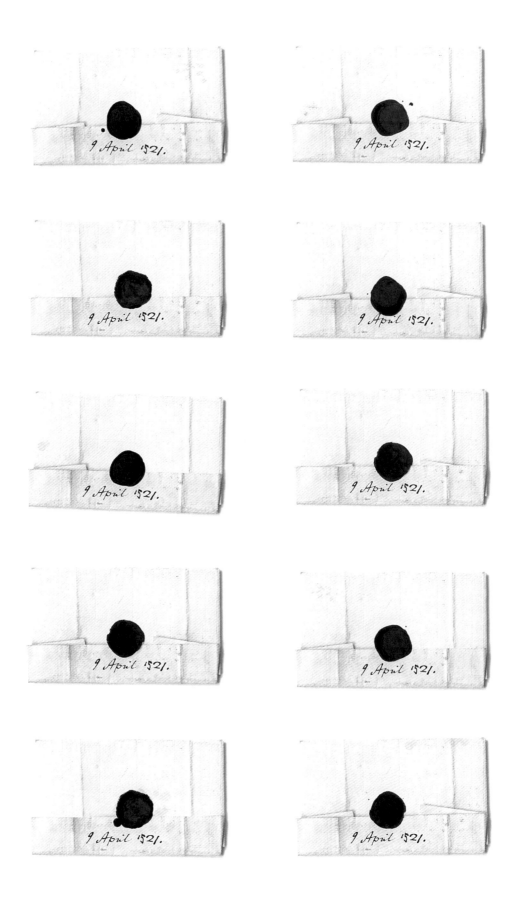

《都鐸王朝》的情書：連戲複本 ←←

拆解腳本的過程形同拆解理智，每次剛開始製作這些表格時，我總會先對接下來即將製作的東西感到興奮，我有那麼多新穎又有趣的作品要完成。但接著，我就會開始焦慮，想著我怎麼可能在這麼短的時間內完成這麼多東西。很少有電影是按照故事順序拍攝的，雖然也有一些著名的例外，像是《E.T.外星人》就幾乎完全按照電影中的時間順序拍攝，因為史蒂芬・史匹柏導演希望小演員能夠忠實表演出與朋友離別的情感變化。《鬼店》原本計劃拍攝一百天，但最後卻花了兩百五十天，因為庫柏力克也按故事順序拍攝，這樣他就可以一邊拍，一邊增補和修改腳本。

一般而言，讓整個劇組四處奔波，並不斷重新安裝所有設備和燈光，這既不符合成本也沒有效率。因此，助理導演會安排整部電影的每一個鏡頭，優先考慮場地和演員的檔期。例如，所有的飯店場景都在幾個星期之內一次拍完，無論這些橋段發生在故事的哪一個時間點。接著，全體工作人員會轉移到另一個場地，稱之為「集體行動」，然後開始拍攝所有的監獄場景。一次把好幾個段落混在一起會讓人感到十分錯亂，而且通常這些段落在故事時間中都相隔很遙遠。就我個人而言，我一點都不想為了高薪去而去擔任場記或是助理導演。

反過來說，我倒十分肯定，當助理導演在安排拍攝順序時，完全不會去考慮就是平面設計。我們身處整個食物鏈的最底端。我第一次了解這殘酷的事實是在《都鐸王朝》（The Tudors）第三季片場，那是我第一份影視平面設計工作。當時我在英國本島訂製了平板印刷的上等皮紙古代地圖，但因為臨時改動了拍攝順序，就算是快遞也無法及時將它送到愛爾蘭。這些地圖在場景中非常重要，依照劇本描述，亨利八世仔細研究了地圖，進而決定如何入侵法國。回想起來，我不太清楚自己當時為什麼會把問題拋回給第一助導。那時他正在喧鬧的中世紀法庭場景「西敏宮」旁忙於指揮，我向他解釋了皮紙、快遞和印刷的情況，並等著他說會修改時間表。但他當然沒有這麼做。最後，我只能將地圖印在當地的繪圖紙上，並在心中記下：永遠不要再為了一件道具去打擾助理導演了。

兩幅美國國旗的鉛筆畫 →

許多像是重拍、多鏡次、反拍（reverse shot）等拍片技巧，都會讓我們陷入連戲的困境。或者說得更具體一點，這會讓我們登上IMDb網路電影資料庫的「穿幫」頁面，這是一個記錄著我們所有重大失誤的無底洞，電影觀眾們會將這一切都精心記錄下來。我很喜歡讀「穿幫」筆記。因為一切都為時已晚，無法改變，反而讓我有點病態地感到著迷。有一些失誤需要經過考究，比如牆上掛的日曆中，日期與星期不相符），有一些則在事後看來十分顯而易見，像是在故事的同一天中，場景突然從下雪的冬天變成綠意盎然的夏天。IMDb的投稿指南試圖引導挑剔的觀眾去找出相關或有趣的失誤——難道這些觀察可以變成派對上的話題亮點嗎？

但網站也不希望觀眾在這個頁面上批評電影創作者的藝術手法，畢竟，我們當然都知道太空中是寂靜無聲的。

大部份頁面上記錄的失誤都是一些歷史時代的錯置，比如一九六〇年代還沒有汽車、十四世紀的小提琴應該是架在腹部而不是下巴。這種糾正正是具有教育意義的，我可以花一個小時來流覽這些資訊，往後我就不會犯相同的錯誤。舉例來說，我不是美國人，所以我沒有停下來思考，在一九五七年夏威夷和阿拉斯加成為美國的一州之前，美國國旗上究竟有幾顆星星，但下次我要畫這面國旗的時候，我就能夠非常肯定了。

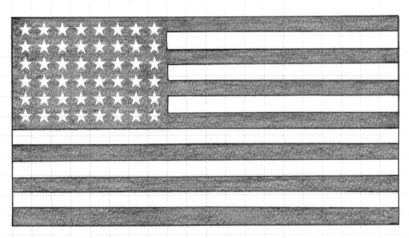

48 STAR FLAG 1912 - 1959

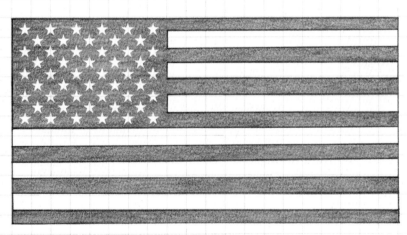

50 STAR FLAG 1960 - PRESENT

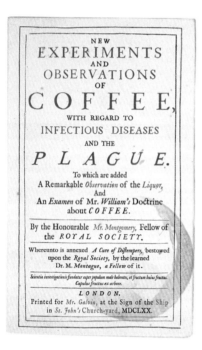

八個咖啡漬

NEW
EXPERIMENTS
AND
OBSERVATIONS
OF
COFFEE,
WITH REGARD TO
INFECTIOUS DISEASES
AND THE
PLAGUE.

To which are added
A Remarkable *Observation* of the *Liquor*,
And
An *Examen* of Mr. *William's* Doctrine
about *COFFEE*.

By the Honourable *Mr. Montgomery*, Fellow of
the *ROYAL SOCIETY*.

Whereunto is annexed *A Cure of Diftempers*, bestowed
upon the *Royal Society*, by the learned
Dr. M. *Montague*, a *Fellow* of it.

*Scientia investigationis fundatur super populum male habentes, et fructum huius fructus.
Capulus fructus ex arbore.*

LONDON.
Printed for Mr. *Galvin*, at the Sign of the Ship
in *St. John's* Church-yard, MDCLXX.

NEW
EXPERIMENTS
AND
OBSERVATIONS
OF
COFFEE,
WITH REGARD TO
INFECTIOUS DISEASES
AND THE
PLAGUE.

To which are added
A Remarkable Observation of the Liquor,
And
An Examen of Mr. William's Doctrine
about COFFEE.

By the Honourable Mr. Montgomery, Fellow of
the ROYAL SOCIETY.

Whereunto is annexed A Cure of Diftempers, bestowed
upon the Royal Society, by the learned
Dr. M. Montague, a Fellow of it.

Scientia investigationis fundatur super populum male habentes, et fructum huius fructus.
Capulus fructus ex arbore.

LONDON.
Printed for Mr. Galvin, at the Sign of the Ship
in St. John's Church-yard, MDCLXX.

NEW
EXPERIMENTS
AND
OBSERVATIONS
OF
COFFEE,
WITH REGARD TO
INFECTIOUS DISEASES
AND THE
PLAGUE.

To which are added
A Remarkable Observation of the Liquor,
And
An Examen of Mr. William's Doctrine
about COFFEE.

By the Honourable Mr. Montgomery, Fellow of
the ROYAL SOCIETY.

Whereunto is annexed A Cure of Diftempers, bestowed
upon the Royal Society, by the learned
Dr. M. Montague, a Fellow of it.

Scientia investigationis fundatur super populum male habentes, et fructum huius fructus.
Capulus fructus ex arbore.

LONDON.
Printed for Mr. Galvin, at the Sign of the Ship
in St. John's Church-yard, MDCLXX.

NEW
EXPERIMENTS
AND
OBSERVATIONS
OF
COFFEE,
WITH REGARD TO
INFECTIOUS DISEASES
AND THE
PLAGUE.

To which are added
A Remarkable Observation of the Liquor,
And
An Examen of Mr. William's Doctrine
about COFFEE.

By the Honourable Mr. Montgomery, Fellow of
the ROYAL SOCIETY.

Whereunto is annexed A Cure of Diftempers, bestowed
upon the Royal Society, by the learned
Dr. M. Montague, a Fellow of it.

Scientia investigationis fundatur super populum male habentes, et fructum huius fructus.
Capulus fructus ex arbore.

LONDON.
Printed for Mr. Galvin, at the Sign of the Ship
in St. John's Church-yard, MDCLXX.

十四個信封（《薇塔與吳爾芙》）

背景中的手寫紙張道具可以先寫好，再用印表機掃描和複印出許多份複本，並在紙張各處塗上一些墨水，使字跡增加一些光澤。但如果是主角道具，那麼以墨水直接寫在適合的紙張上會更好。如果有某個道具是要用來被破壞的，也就是說，道具將被演員撕碎，或者再劇情中被濺上鮮血，我們就會製作二十個複本，以防導演想要多次拍攝同一個段落。「破壞」道具不一定是有血跡或被撕爛，光是演員依照腳本指示在鏡頭前打開一封信，就可能需要二十份道具複本。

ROMA
·HOTEL·
HASSLER

Mrs Virginia Woolf
52 Tavistock Square
London W C 1
England

ROMA
·HOTEL·
HASSLER

Mrs Virginia Woolf
52 Tavistock Square
London W C 1
England

ROMA
·HOTEL·
HASSLER

Mrs Virginia Woolf
52 Tavistock Square
London W C 1
England

ROMA
·HOTEL·
HASSLER

Mrs Virginia Woolf
52 Tavistock Square
London W C 1
England

...lite Publisher, and I shall get
... regrets

HOTEL HASSLER·ROMA

DIRIMPETTO ALLA STAZIONE
COMPLETAMENTE RINNOVATO
ACQUA CORRENTE, /EGNALI LUMINO/I
E TELEFONO INTER-URBANO IN OGNI CAMERA
CLIMANCE ASCENSORE E SERVIZIO
RINOMATO RISTORANTE
PREZZI MODICI

14 April

My darling Virginia,

Will you come away with me next year?
I don't believe one ever knows people in their
own surroundings. One only knows them away;
divorced from all the little strings and
cobwebs of habit.

Neither of us is the real, essential person
in these letters. Either I am at home and you
are strange, or you are at home and I am strange.
Here we should both be equally busy and equally
real. Will you come away with me?

I hope that no one has ever yet, or
ever will, throw down a glove I was not ready
to pick up. You asked me to write a story for
you. On the peaks of mountains, and beside
green lakes, I am writing it for you. I shut
my eyes to the blue of gentians, to the coral
of androsace; I shut my ears to the bawling
of rivers, I shut my nose to the scent of
pines; I concentrate on my story. Perhaps you

123

十二卷錄音帶

十二卷錄音帶上都有清晰可辨的手寫字，這是一份情節製作物，會在鏡頭前被銷毀。

第五章

語言文字

在電影佈景的平面圖案上加入一些語言文字,可以增強戲劇性,像是老派的廣告標語可以創造出某種氛圍,指示牌可以幫助故事發展,就算是微小的文字細節,也能帶出完全不同的時間和地點。

若要再現一座城市裡的標誌，有關歷史街道的攝影書籍便是絕佳的參考資源。在攝影師菲力浦・戴維斯（Philip Davies）的作品集《消失的倫敦全景》（Panoramas of Lost, 2011）中，有張手繪廣告招牌的照片，招牌高高懸掛在咖啡館的外牆，上頭以稍成塊狀的無襯線字體寫著「燉鰻魚與馬鈴薯泥」。然而，最精彩的則是下面那一行，字體寫得非常華美：「隨時享用」。鰻魚是當時的速食，形同十九世紀的熱狗。

拍攝《英國恐怖故事》期間，我們將現代都柏林改造成維多利亞時代的倫敦，戴維斯的這本攝影集就成了我們的美術部門工作手冊，每一頁美麗的黑白照片旁，都貼滿了顯眼的便條紙，標記出最好的視覺參考資料。少了這些參考文獻，就很難想出符合那個時代的廣告文案。雖然我們可能想出「鰻魚和馬鈴薯泥」，但「隨時享用」就不一定會出現在腦海中了。

在街道佈景中，我們只需要在那些高掛的商店招牌寫上精緻的文字，便能打造出特定時代的場景。比如說，維多利亞時代牙醫診所外的廣告上寫著「無痛拔牙」，現在看來似乎有點誇張，但在十九世紀看牙科，絕對不會是無痛的。挖出爛牙是治療牙痛的常用方法，而牙痛也很常見。一八七四年，糖稅被廢除，工人階級終於買得起糖果了。然而，安裝新牙卻沒那麼便宜，盜墓者總以超高價格出售人類的犬齒和臼齒，因為他們必須在漫長寒冷的夜晚裡，將這些牙齒從屍體的口中取出來。當鋪的櫥窗裡擺滿了這些長期盜墓行為的證據，從木製義肢、眼鏡到全副牙齒都有，但他們的窗戶上卻寫著，「正當來源的貨品」才能典當。

人人最終難逃一死，而倫敦當時常有殯葬業者四處友善地推銷，他們的口號是「為所有階級量身打造葬禮」，相較於當今企業避之不談的社會階級，他們倒是大方承認了。維多利亞時代倫敦人的平均壽命只有三十八歲，至於出身貧困家庭的孩子們，若能活到五歲以上就已是萬幸。在這座城市裡，猩紅熱、肺結核、霍亂和天花十分普遍，當時他們公告了一些有關疾病預防與治療的各種資訊，現在看來似乎都大有問題。

霍亂是世上最致命的疾病之一，經由受污染的水源感染腸道。然而，十九世紀的英國，人們卻相信它是透過「空氣中的味道」傳播，或是其他虛假又迷信的污染過程。因此，當時人們普遍認為霍亂疫情完全無法防堵。在倫敦的貧民窟裡，又怎麼可能驅散這股「髒空氣與恐懼」？人們無能為力，只能放棄，髒空氣與恐懼無所不在。

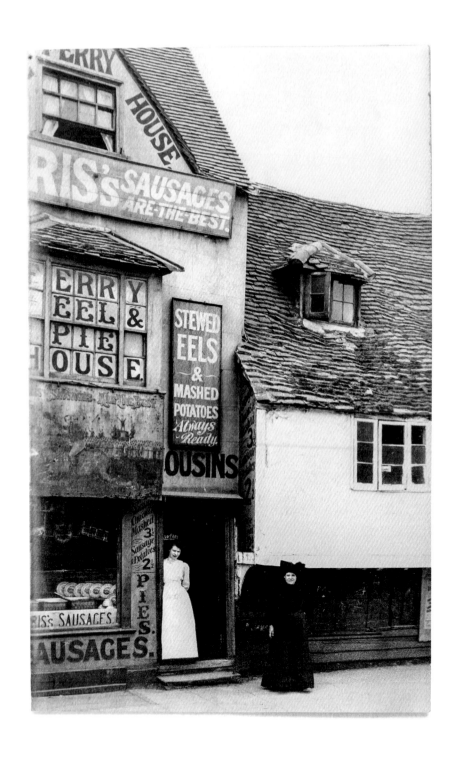

燉鰻魚與馬鈴薯泥：隨時享用 →

《英國恐怖故事》街道場景中的招牌題字，一八九一年東倫
敦及周邊地區。

街頭海報:霍亂!(《英國恐怖故事》)

霍亂曾是倫敦最大的殺手之一,而有關這種疾病的錯誤資訊不斷擴散,幾乎和疾病本身的傳染力一樣強大。這張街頭海報上的文字是根據某位醫生發表於一八三二年的文章改寫的,文章題名為〈專為大眾設計的霍亂疫情的簡單實用指南〉。但這篇文章其實只是加劇了人們的焦慮,讓人們以為自己會因為害怕而染上疾病。「保持冷靜沉著,」他警告所有人。「原本遭到壓抑的恐懼情緒一旦開始滋長,就會引發疾病。」這些建議非常過時又不正確,霍亂現在已知是由遭污染的食物和飲水傳播,而不是「髒空氣」。

CROWN AND BRIDGE
WORKERS.
—
PAINLESS
TOOTH
EXTRACTION.

牙醫診所的廣告招牌（《英國恐怖故事》）

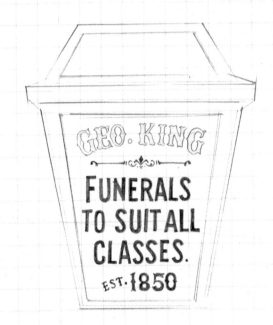

殯葬業者的街燈廣告（《英國恐怖故事》）

Price— ONE PENNY.

HOW TO WRITE TELEGRAMS PROPERLY.

BELFAST:

HAROLD MAGUIRE AND CO.,
GENERAL PRINTERS, ETC.
1909

《電報撰寫指南》手冊（《鐵達尼號：血與鋼》）

「眾所周知，電報措辭確實需要經過謹慎考量，文字務必謹慎安排，以傳達簡潔的資訊，勿將字數浪費在非必要的訊息上。」電報就彷彿一九二八年的Twitter，要在有限的字數內進行表達。除此之外，這本小冊還收錄了一些小竅門，教讀者寫出有禮貌的電文：「一定要用『請』這個字，養成習慣，所有的通訊中都要加上這個字。」我們為《鐵達尼號：血與鋼》製作書桌上的背景裝飾時，就引用了英國電報局在二十世紀初公告的這些真實指南。除了幾位扮演辦公室員工的演員之外，不太可能有任何人會拿起這本小冊子來閱讀。但由於任何一個鏡頭都可能需要拍好幾個小時，我們知道至少有一位《英國恐怖故事》的臨時演員很仔細地打量過殯葬業者的街燈廣告。

R.M.S."TITANIC".

APRIL 14, 1912.

LUNCHEON.

CONSOMMÉ FERMIER COCKIE LEEKIE

FILLETS OF BRILL

EGG À L'ARGENTEUIL

CHICKEN À LA MARYLAND

CORNED BEEF, VEGETABLES, DUMPLINGS

FROM THE GRILL.

GRILLED MUTTON CHOPS

MASHED, FRIED & BAKED JACKET POTATOES

CUSTARD PUDDING

APPLE MERINGUE PASTRY

BUFFET.

SALMON MAYONNAISE POTTED SHRIMPS

NORWEGIAN ANCHOVIES SOUSED HERRINGS

PLAIN & SMOKED SARDINES

ROAST BEEF

ROUND OF SPICED BEEF

VEAL & HAM PIE

VIRGINIA & CUMBERLAND HAM

BOLOGNA SAUSAGE BRAWN

GALANTINE OF CHICKEN

CORNED OX TONGUE

LETTUCE BEETROOT TOMATOES

CHEESE.

CHESHIRE, STILTON, GORGONZOLA, EDAM,
CAMEMBERT, ROQUEFORT, ST. IVEL,
CHEDDAR

Iced draught Munich Lager Beer 3d. & 6d. a Tankard.

WHITE STAR LINE

TRIPLE SCREW STEAMER "TITANIC"

2ND. CLASS

APRIL 11, 1912.

BREAKFAST.

FRUIT

ROLLED OATS BOILED HOMINY

FRESH FISH
YARMOUTH BLOATERS

GRILLED OX KIDNEYS & BACON
AMERICAN DRY HASH AU GRATIN
GRILLED SAUSAGE, MASHED POTATOES
GRILLED HAM & FRIED EGGS
FRIED POTATOES
VIENNA & GRAHAM ROLLS
SODA SCONES
BUCKWHEAT CAKES, MAPLE SYRUP
CONSERVE MARMALADE
TEA COFFEE

WATERCRESS

WHITE STAR LINE.

R.M.S. "TITANIC." APRIL 14, 1912.

THIRD CLASS.
BREAKFAST.
OATMEAL PORRIDGE & MILK
SMOKED HERRINGS, JACKET POTATOES
HAM & EGGS
FRESH BREAD & BUTTER
MARMALADE SWEDISH BREAD
TEA COFFEE
DINNER.
RICE SOUP
FRESH BREAD CABIN BISCUITS
ROAST BEEF, BROWN GRAVY
SWEET CORN BOILED POTATOES
PLUM PUDDING, SWEET SAUCE
FRUIT
TEA.
COLD MEAT
CHEESE PICKLES
FRESH BREAD & BUTTER
STEWED FIGS & RICE
TEA
SUPPER.
GRUEL CABIN BISCUITS CHEESE
Any complaint respecting the Food supplied, want of attention
or incivility, should be at once reported to the Purser or Chief
Steward. For purposes of identification, each Steward wears a
numbered badge on the arm.

鐵達尼號上的菜單（《鐵達尼號：血與鋼》）

鐵達尼號首航的餐廳菜單上寫道，依據客人的艙等，餐點品質也會有所不同。在頭等艙裡，你可以享用燒牛肉和馬里蘭雞，搭配大杯冰啤酒。二等艙中，則是雅茅斯醃熏鯡魚和烤牛腎。這份菜單印在空白明信片的背面，下船時還能用來寄給朋友。至於三等艙的菜單上，底部有一行標語寫著，若有「任何對餐點的不滿，或服務不周及無禮的情況」，都可以進行申訴。但即便如此，乘客也不可能對於端上桌的稀粥和醃菜品質感到滿意。更何況，當發生緊急事故時，三等艙乘客也會是最快被拋下的一群人。原本的菜單上其實印有鐵達尼號的照片，但這裡展示的三件製作物並未如實還原，因為我們沒有額外的預算來支付版權費用。

當鋪櫥窗（《英國恐怖故事》）→

當鋪櫥窗上的「To-day」（今天）中間有個連字號，這是英國古裝劇中最常見的老式拼寫。而這是也一個很好的例子，讓我們看到小小的標點符號如何襯托出整個街道佈景的復古感。我們也可以藉由許多人名的縮寫來看出時代差異，比如湯瑪斯縮寫為「湯斯」、瑪麗縮寫為「瑪」、喬治縮寫為「喬」，當時稅務員會將這些人名縮短，因為書寫工具很珍貴，而且以沾水筆書寫是個緩慢又困難的工程。在整個十九世紀中，字詞縮寫一直十分常見，手繪的廣告看板上也能看到。《牛津英語詞典》（Oxford English Dictionary）指出，雖然「holiday」（假日）這個詞早在西元九五〇年的文本中就已經出現，但一直到十九世紀末，人們都還是以「holy days」（聖日）一詞來指稱假日。這些縮寫在車水馬龍的街道場景中都是很小的細節，但我們還能再更仔細一點，就連文法和標點符號也可以看出時代差異。這些廣告招牌大部份的文案後面都標上了句點，現在幾乎完全不會這麼做了。到了二十世紀，這種用法似乎就已經被英國出版業淘汰，一九二八年八月十二日星期一的《泰晤士報》標題結尾都還有個句點，但隔天，也就是星期二，便消失了。在復古道具上看到這過時的句點十分有趣，這表示在其他某處，有某位設計師全心投入了他的道具設計——我們多半都會確保自己不要因睡眠不足而粗心大意。雖然文字和符號可能在一夜之間就從某些出版品上消失，但好幾十年之後，這些使用習慣又再次重新回到了街道佈景中的每一塊廣告看板上。

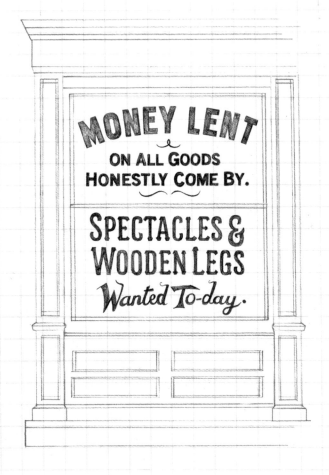

FOR WASHINGTON H'TS., THE
BRONX AND QUEENS TRAINS
← TAKE LEFT ON EXIT

SPITTING
ON THE PLATFORMS OR OTHER
PARTS OF THIS STATION
IS
UNLAWFUL
OFFENDERS ARE LIABLE
TO ARREST

BY ORDER OF THE BOARD OF HEALTH

BMT LINES BROAD ST

↑ EXIT TO STREETS | W US

BROAD ST DOWNT

WARNING DO NOT L

COURT ST. SUBWAY
UPTOWN TO 59TH ST. & QUEENS
DOWNTOWN WHITEHALL ST. SOUTH FERRY
BROOKLYN AND CONEY ISLAND

24HR SERV
B'KLN AND Q
YOUR COU
IS APPREC

THIS SIDE FOR ———
NTOWN TRAINS

THIS SIDE FOR ———
OWN TRAINS

 ER

BROAD STREET
MANHATTAN

JAMAICA
NASSAU STREET

K DO NOT RUN
ANDRAILS ON STEP

DO NOT SMOKE
OR CARRY A LIGHTED
CIGARETTE, CIGAR OR
PIPE ON ANY STATION,
TRAIN, TROLLEY, OR BUS.
———
SPITTING
OR THROWING
PAPERS OR OTHER LITTER
ON CAR OR STATION
FLOORS IS A VIOLATION
OF THE SANITARY CODE.
———
OFFENDERS WILL BE
PROSECUTED.

BOARD OF HEALTH BOARD OF TRANSPORTATION
THE CITY OF NEW YORK

TO BAYRIDGE
TH ST

BROOKLYN
MANHATTAN
TRANSIT

AN OVER PLATFORM

TO
NS
SY
ED

EXIT TO WILLIAM ST
FOR SERVICE TO NEW
LOTS AND FLATBUSH
LEXINGTON AV AND
BROADWAY EXPRESS

CHAMBERS ST

CONEY ISLAND

6TH AVE

BROADWAY

DITMAS

紐約地鐵標誌（《間諜橋》）

電影設計的一大重點就是要確認好故事的時間和地點。我們還會更進一步，確立好佈景中要使用的語言，藉此推動敘事。《間諜橋》的開場是一段追逐戲碼，眾人在一九五〇年代的布魯克林區狂奔。藝術總監要求我們，其中一塊地鐵標誌上要寫著「請勿奔跑」，在演員們依照腳本指示展開追逐的那場戲裡，他們的頭頂上就正好掛著這塊標誌。這種做法十分具有下意識刺激效果，幾乎變成了一種刻意對比的手法，但我們展現鏡頭前的所有物件本來就都有各自的功能。在這個例子中，無論觀眾是否有察覺，平面設計都輔助了腳本情節，並推動故事前進。

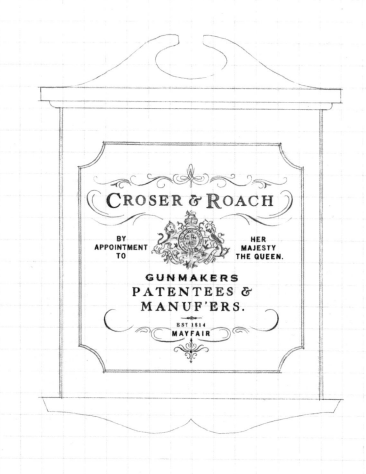

製槍廠的招牌（《英國恐怖故事》）

街頭海報：火柴販罷工行動（《英國恐怖故事》）

《英國恐怖故事》的貧民窟場景是在都柏林的健力士酒廠（Guinness Brewery）一帶重新打造出來的。這個地方已經算是城市裡比較好的區域，但等到我們的影集開拍時，幾乎已經認不出它原本的面貌，因為美術部門用一大堆瓦礫和破舊的市場攤位重新妝點了一番。製景部門建造了巨大的圍欄來遮蓋任何眼睛所及的現代建築，而我們製作了大量的政府宣導標語貼在上面，警告民眾慎防遊民、性侵犯及重大傳染病。

這些街景都在定場鏡頭（establishing shot）中出現，從人群上方以起重機拍攝，好在場景切換到室內劇情之前，觀眾就能快速瞭解室外環境。當然，任何一張街頭海報都不可能獲得自己的特寫，但這些物品都是為了打造出更加逼真的世界而製造，在這個世界裡，數百個臨時演員正熙來攘往著。

有些臨演們穿著厚重的戲服，並在毛毛雨中站了一整天，但這些都還不夠悲慘，有的人還必須化上「下巴壞死」的妝容。「磷毒性顎骨壞死」是一種火柴廠工人的職災，他們因為接觸有毒的磷物質，造成了顎骨損壞。火柴頭上的白磷會釋放出一種氣體，鼻子長期吸入這些氣體並堆積在顎骨中，牙痛和牙齦腫脹接踵而來，接著會化膿，嚴重感染磷毒的顎骨甚至會在黑暗中發出綠色螢光，最後，患者會因腦損傷及器官衰竭死亡。當時唯一已知的治療方法就是以手術將下巴切除。一八八八年，倫敦火柴販試圖以罷工來呼籲停用白磷原料，宗教團體「救世軍」（Salvation Army）因而開設了一間新的火柴工廠，並且只使用相對安全的紅磷。

Attention Matchgirls!

WE CALL FOR STRIKE!

TO-DAY, at 3 o'clock.

SEVENTEEN cases of 'Phossy Jaw' remain
unreported by Matchstick Factory Owners.
Phossy Jaw will TAKE YOUR JAW.

-------------- THERE IS --------------

NO KNOWN CURE.

Strike to be led by

Mrs. M. LEVERETT

of the

WOMEN'S TRADE UNION ASSOCIATION.

PHOSPHORUS IS A DANGER TO US ALL.

LIMEHOUSE HALL,
Bet. King St.
and Cinnamon St.,
Shadwell.

GOOD
SPEAKERS
will be
PRESENT.

後台標誌（《英國恐怖故事》）

當時大型劇場演出的懸吊技術組通常是下班後的水手來打工，他們在船上經常以吹口哨當作指令來互相合作。為了避免錯亂，劇場嚴禁後台的其他工作人員吹口哨，這樣演員才不會因為錯誤的指令而被頭上的吊具砸死。至於「孔雀羽毛」這個特殊的禁令就不那麼切實了。當時有個迷信，人們認為孔雀羽毛上的「邪惡之眼」會讓演員莫名其妙忘詞。這塊琺瑯材質的看板陳設在《英國恐怖故事》的大木偶恐怖劇場後台，由我們的看板師傅勞倫斯・奧圖爾（Laurence O'Toole）繪製在全新的鋁材上，再鑽孔、銼邊，並塗上深色顏料，打造出生鏽破舊的質感。

戲院標誌（《英國恐怖故事》）

火柴盒與飯店文具（《間諜橋》）

二十世紀中葉的飯店文具上，大多都會以文案來強調每個房
間均有浴缸，還稍微令人起疑地保證房間具有「防火」設
計。這種承諾實在不該印在紙上，畢竟當火災發生時，易燃
的室內油漆與清漆，樓梯數量也不夠，美國飯店在當時可是
出了名的危險。萊瑟姆飯店是片中俄羅斯間諜魯道夫遭FBI
追捕時，所暫住的廉價旅館。而他的律師詹姆士造訪華盛頓

時，下榻在亞當斯飯店，就位在白宮的正對面。飯店房間內
的場景不一定都是在真實飯店拍攝的，但這些小道具可以製
造出真實感。

200 *Rooms* # Hotel Latham 200 *Baths*

========== FIREPROOF ==========

Manhattan, New York

LICHTENSTEIN & Co.

ll TAILOR SUPPLIES & REMNANTS

lININGS WOOLENS MOHAIR
TRIMMINGS LINENS *muy barato!*

ODO PARA SASTRERIA 515-0198 CORTE PARA PANTALONES

GOODALL RUBBER CO. INC.
INDUSTRIAL RUBBER PRODUCTS

DECK HOSE	SEWER FLUSHING	METAL LINED HOSE	ACID PINCH VALVE
ACID HOSE	PAINT SPRAY HOSE	OXY-ACETYLENE	AUTOMOBILE RADIATOR
DUST EXHAUST	SAND BLAST HOSE	SYNPLASTIC	HOT WATER HOSE
CHIPPER AIR HOSE	SOLVENT	VACUUM AIR BRAKE	SEMI-METALLIC HOSE
FLUE CLEANER	STEAM CLEANING	VACUUM HOSE	SPRAY HOSE

RY GOODALL WHEN YOUR NEXT INQUIRIES GO OUT. BRANCHES IN ALL PRINCIPAL CITIES.

lOEW'S KINGS
THEATRE

027 FLATBUSH AVENUE, BROOKLYN

THURS. FRI. NOV. 7-8

GRANT WILLIAMS · RANDY STUART

THE INCREDIBLE
SHRINKING MAN

THE MOST INCREDIBLE STORY
THE SCREEN HAS EVER TOLD

Come on in, or smile as you pass!

NO U TURN
DEPT OF TRAFFIC

NO PARKING 8 AM TO 1 PM TUES. THURS. SAT.
DEPT OF TRAFFIC

5TH AV
WASHINGTON MEWS

AV OF THE AMERICAS
BROOME ST

E.68 ST
F.D. ROOSEVELT DRIVE

FULTON
HUDSON AV

POLICE DEPT
ONE-WAY

POLICE DEPT
ONE-WAY

街道標誌（《間諜橋》）← ←

當我們在現實世界中出外景，而不是在片場或攝影棚裡的時候，我們就必須製作出許多平面製作物，來覆蓋街道上原本的現代標誌和廣告看板。如果是用寬臂起重機或無人機拍攝，那麼其中一些細節就可以在後製期間，由視覺效果團隊用我們製作的數位檔案加上去，例如屋頂上的標誌。至於在地面上，通常整個區域都需要用實體的標誌來裝飾，打造出一個符合情節的逼真背景，有時甚至會為單一場景製作數百個訂製的佈置物。

務必要檢查每一個小細節，因為我們永遠不知道當劇組封街拍攝時，導演會指示演員停在哪一個招牌旁邊。任何拼寫、

不符時代背景的名稱和物價等等，都需要經過仔細檢查。我第一次擬好《間諜橋》開場的路牌設計時，裡頭包含一家理髮廳的廣告看板，上面宣傳理髮只要零點二五分美金，藝術總監亞當·斯托克豪森立即告訴我：就算是經濟實惠，一九五七年剪頭髮也不可能這麼便宜。我確認了我的參考資料，他說得對，我是根據一張一九三〇年代的廣告設計這塊看板，年代久遠了許多。美術部的助理山繆·巴德（Samuel Bader）做了一些研究之後，我們把將廣告改成了一點五塊美金，光是那多出來的一元，在當時就會造成很大的差異。

咖啡廳菜單（《英國恐怖故事》）→

我們虛構的大都會咖啡廳的午餐菜單上，驕傲地強調餐點「美味而實惠」，湯「保證是熱的」，咖啡「媲美巴黎的品質，並附贈一顆雞蛋」，大概是放在咖啡杯旁邊。這份菜單戲劇化的第一行文案寫著：「What are the wild wave's saying?」（有哪些廣大好評）。這句話的文法有誤，但我們是複製了真實的廣告原句。「wild wave」（廣大好評）是指人們對咖啡館美食的評論，後面的撇號則完全是多出來的。我自己通常會避免犯這樣的錯誤。但值得一提的是，有些世界上最偉大的作家也會誤用撇號，比如英國小說家珍·奧斯汀（Jane Austen）使用所有格「its」（它的）時，總是寫成「it's」（這是），而文豪莎士比亞寫名詞複數加「s」時，也總是寫成「's」。一般來說，電影道具一定要避免誤用撇號的災難，畢竟，沒有任何平面設計師想成為讀者憤怒登報投訴的對象。

WHAT ARE THE WILD WAVE'S SAYING?

In spite of all opposition Visitors declare
that the Best Place in Soho for
DECENT but REASONABLE luncheon is

THE

"Metropole"

1^d	A POT of FRESH MADE TEA or COFFEE with Roll and Butter.	**1^d**
2^d	FRUIT TART or MILK PUDDING.	**2^d**
7^d	TEA or COFFEE with SHRIMPS and EGG & WATERCRESS, ad lib.	**7^d**
3^d	SMOKED MACKEREL with butter & one LARGE POTATO.	**3^d**
6^d	Plate of COLD MEAT or HAM with Bread and PICKLES.	**6^d**
1^s	CUT from PRIME JOINTS with two VEGETABLES and BREAD.	**1^s**
1^s	LOIN CHOP or RUMP STEAK with two VEG. and BREAD.	**1^s**
7^d	OYSTERS :- choicest brands served by the dozen.	**7^d**
4^d	FRENCH COFFEE as served in PARIS with ONE EGG.	**4^d**
4^d	BACON, per rasher.	**4^d**
5^d	TWO EGGS, with a BLOATER or a KIPPER.	**5^d**
3^d	SOUPS, all kinds, guaranteed HOT with BREAD.	**3^d**
1^d	PIPING HOT mug of CHOCOLATE.	**1^d**
1^d	GINGER BEER, LEMONADE, GLASS OF MILK, etc.	**1^d**

OUR TEA IS UNSURPASSABLE AT 1/? PER CUP
BUT WE MAKE FOR ANY CUSTOMER FRESH AT 2/?

日文圖案（《犬之島》）→

畫出其他語種的文字是一項挑戰，就算在魏斯‧安德森的
《犬之島》劇組工作了九個月，我還是不確定日文的三種不
同文字符號要如何使用。這部電影的首席平面設計師艾莉
卡‧朵恩（Erica Dorn）會將文字與風格建議一起傳給我，
讓我以手繪的方式複製下來，並小心翼翼地將它們繪製成招
牌，因為我知道要是隨便添加任何多餘的修飾，都可能無意
中完全改變文字的含義。

"RIDE"　　　　　　"PAGODA SLIDE"

第六章

工具

拍片是一種現場經驗，需要許多實體的製作物。我們會儘量避免在
後製時才用電腦將製作物加上去，只要情況允許，電影設計部門都會
提供沾水筆、打字機或假血漬等任何東西。

剛從電影學院畢業時，我到《都鐸王朝》劇組接受面試，當時我還覺得，在這部影集的時空背景裡，平面設計這樣的職位根本還不存在，劇組為什麼會需要招募全職平面設計師呢？我之前就看過前兩季，雖然我注意到許多美麗的服裝設計和令人驚豔的佈景，但我真的沒有看出任何平面設計圖案。會是玻璃花窗嗎？電影學院教我如何操作攝影機、如何設定劇本格式，但卻沒有教平面藝術。而在我的廣告產業經歷中，我做了許多網路版位、商標和雜誌內頁，當然也完全沒碰過任何與十六世紀古裝劇有關的東西。

　　從商業設計轉往電影設計是一段曲折的學習之路。我很快就發現，亨利八世的宮廷中雖然沒有平面設計師，但這不表示這部劇不需要任何平面設計。當時的平面設計都是由工匠製作的。比如說，如果國王想砍妻子的頭，他就會需要頒布一張死刑詔令，而如果如果他需要一張詔令，那麼他就得找位書法家來撰寫。在十六世紀，所有皇家文書的排版和書寫風格都是由抄書吏負責的，而現在的電影製作中，平面設計師們的工作，就是要仿製出他們曾經創造的東西，有時也可以聘請專業的手寫藝術家來協助撰寫。

　　當時是我第一次準備在劇組待上一整個季度，感到非常興奮。以愛爾蘭的天氣來說，那是個美好的夏天。片場裡總是擠滿等著上陣的臨演，而諸位僕人、朝臣、騎士及公主殿下們，則各個頭戴帽子或身穿束腹，站在一旁抽菸、喝咖啡。助理導演指揮著大家戴好耳機和對講機，而兩個後台人員正扛著王座穿過停車場，光是看到這一幕，就讓我覺得好快樂。這就是拍電影啊！有一次午休時間，我端著托盤穿過員工餐廳，英國國王還微笑著向我問好，我完全不知道怎麼回應，差點驚慌失措地行屈膝禮呢！

　　其他工作人員看到演員似乎都不會大驚小怪。他們直呼強納森·萊斯·梅爾（Jonathan Rhys Meyers）為「強尼」，有天晚上大家去市中心的時候，我還看到一位製片助理請喬絲·史東（Joss Stone）吃洋芋片，一切都那麼稀鬆平常。我想我就是不太擅長和演員交談，對我來說，他們似乎是超凡脫俗的，就像外星來的一

樣，是某種長得非常好看的外星人。我覺得躲在我的平面設計辦公室裡，獨自練習製作茶漬和蠟封更自在一些。這也無妨，因為我確實有很多東西要練習。

雖然我的商業設計經驗可以運用在某些地方，畢竟為劇中任何時代做設計，都必須理解排版原則，但面對製作實體或觸覺道具的工法時，我就感到不知所措。甚至一想到要訂購第一批紙張時，我就感到手足無措，到底該用哪種紙質來偽裝成羊皮紙或上等皮紙才對？我要去哪裡訂購？應該花多少錢？我的繪圖紙會不會打破美集三百萬的總預算？

我突然發覺，電影碩士學位並沒有教我製作道具或預算分配等實用技能，幸好，劇組即將離任的平面設計師皮拉爾・瓦倫西亞（Pilar Valencia）回來為我做了一些快閃訓練。皮拉爾十分了解佈景平面設計和仿舊手稿製作，她善於鼓勵新手，又對自己的知識毫不保留，在短短的五天裡，她給我上了一堂非常完整的速成課，從劇本拆解到使用羽毛筆都涵蓋其中。就像製片廠裡的每一天一樣，一個星期很快就過去了，就在我們一起工作的最後一天，她離開美術部門之前，拍了拍我新買的桌上型印表機，對我說：「從現在起，這台機器就是你最好的朋友。」她這段話反而加深了我日益增長的焦慮感，除了一連串待解決的疑難雜症之外，我還要去學習操作許多不熟悉的硬體設備。

儘管如此，在這無止盡的難題中還是有需多美好的事情發生，而且我對這部作品的喜愛也大幅降低了恐懼感。我學會了不要去擔心打破預算，相較於美術部門其他同事採買的必需品，比如復刻漢普敦宮需要的材料，我們製作平面道具用到的工具，幾乎形同不花半毛錢。而且，我想起一位風景畫家曾告訴過我：「要觀察，而非索取」。道具經常在最後一刻被要求改變，我不再像個新手一樣犯錯，越來越懂得事先備好材料，小辦公室裡開始堆滿了各種紙張、針線、緞帶、珠子、繩子和膠水。

影集的藝術總監湯姆・克羅伊（Tom Conroy）採取親手製作策略，鼓勵我們盡量自製道具，而極具洞察力的搭景師克里斯皮安・沙利斯（Crispian Sallis）則大力幫助我學會觀察細節。幾個星期過去，我也開始發現，一座電影佈景中，總有來自各行各業的專家，有木匠、裁縫或畫家，我花了許多時間待在道具工作室，看著模型師傅為我的卷軸做好固定裝置，他還教我如何為紙張上色、製作勳章和硬幣模型，做好之後將模型上色，看起來就會真金一樣。

這與我在廣告業的工作相去甚遠，當時從我進到辦公室開始一直到下班，我都只需要盯著電腦螢幕而已。但在電影製片廠裡，只要拍攝過程順利，製作道具就像是玩耍一樣，像我們小時候會做的那些東西，以前我會和媽媽在廚房裡做紙漿，或繪製我們埋在後花園樹叢裡的藏寶圖。我在這裡找到了工作，這是一個我以前聽說過，但卻很難想像的世界，來到這裡就彷彿是一段翹家加入馬戲團的歷險。

針線與緞帶

針線、緞帶、細繩和其他用來裝飾製作物的零星工具，都是
我在《都鐸王朝》兩季之後用剩的。

Illustrious & most gracious Sovereign,

I write faithfully to you on this day the twenty & sixthe of Auguste, your Majesty, with news from the Courte of Kynge Henry the eyghth here in Englande. I wish that I had been able to write you prior, but I was struck again in my righte-hande with this dreaded gout so that, until yester morning, I coulde not barely hold a pen.

Lord Winchester has lately been taken ill also, though not by the return of the sweating sickness as previously feared. Nevertheless, he had to disperse of his household and withdrawe to a house neare my own lodgings, and so there was opportunity to do him some civilities. On his arrival he came to dine with me, and, from an early houre until late, we conversed of public affaires, as of the Turks and the detestable practices of the Frenche. The following daye I invited Lord Winchester again to dinner, this time together with Secretary Vrisle, who is no less well inclined and has no less influence with the Kynge, and who was of the opinion that I shoulde take occasion to speak with the Kynge and repente his last persuasions, whiche woulde marvellously rebut the Frenche practices & advance those of the closer amity. And so on the sixteenthe I sent for audience, which was granted for the eighteenthe, when the Kynge received me a little more cordially than usual and thanked me for my affection to the closer amity & good offices, and said he was glad that things shoulde be treated by me, to whom

大使夏普義的信（《都鐸王朝》）

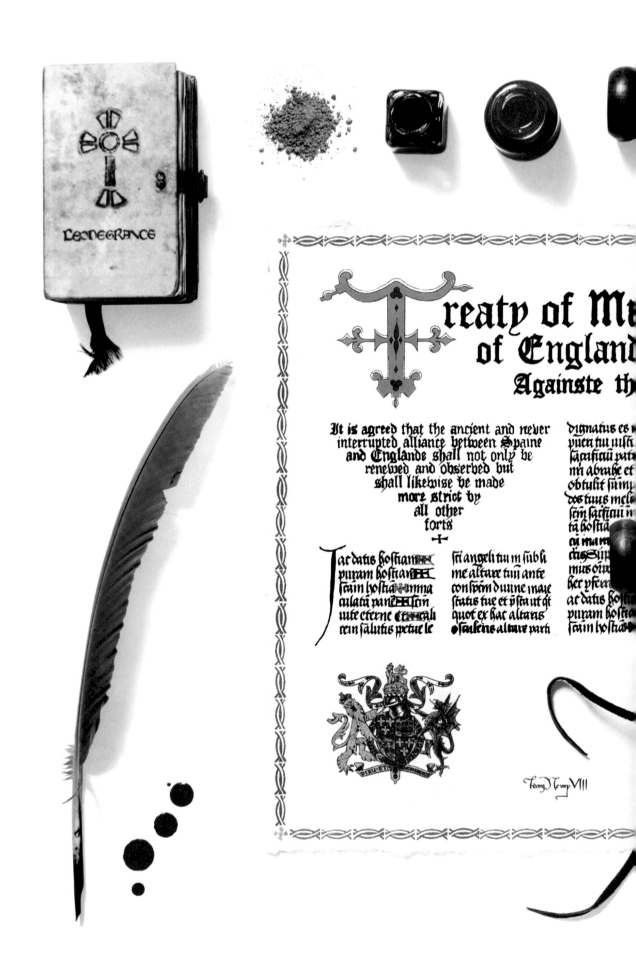

凱薩琳的信（《都鐸王朝》）→

為歷史劇找到合適的手寫藝術家經常是件困難的事。他們不僅需要熟練那個時期的各種字體，還得擔任演員的手寫替身，因此他們的性別、年齡和膚色都還必須與角色相符。這聽起來可能很奇怪，尤其我們更常聽到演員親自上陣演出性愛場面或騎馬特技，但在特寫鏡頭上寫字確實可能是一件更為複雜的任務。

愛爾蘭手寫藝術家蓋瑞斯·科爾根（Gareth Colgan）為《都鐸王朝》創作了大約二十幅不同的作品，採用數種不同的書寫形式，都是以那個時代斜體和哥德草寫體來作變化。書法風格會依據國家和時代而有所不同，比如義大利人寫的文字看起來會與英國人寫的大不相同。這些字體上的差異我完全聽從蓋瑞斯的意見，他十四歲就開始練習書法藝術，在劍橋地區從事謄寫與字母雕刻工作，每次他來片場等待上戲時，人們總會看到他在閱讀一些有關古文字史的厚重書籍。蓋瑞斯的雙手非常適合《都鐸王朝》中的許多角色，只要符合男性、白人、中等身材的條件都可以。在整季的拍攝過程中，他一共來到片場五、六次，總是在黎明時分和其他演員一起進場，每次都穿著「半身戲服」。服裝部門會為所有替身演員提供角色的外套和襯衫，還有任何可能以某種方式出現在鏡頭前的大羽毛帽，好讓他們的袖口在鏡頭前和原本的角色是相同的。無論劇中的服裝多麼精緻或多麼符合史實，書法替身的下半身服裝都可以是牛仔褲配球鞋。

《都鐸王朝》第四季在動盪的一五三九年展開，開場中，法國大使夏普義有一段手寫信的特寫鏡頭，他正要將英國宮廷的最新八卦彙報回國。劇本描述那是一個炎熱的夏日，汗珠順著夏普義的額頭滾落到他面前的信紙上。我們這裡的夏日天氣不錯，但沒有熱到會流汗的程度，因此，蓋瑞斯不得不和一位道具員合作，道具員爬上折疊梯站在他的頭頂上，並用定量吸管滴水，看起來就像汗水從他的額頭上滴落一般。夏普義在現實中是都鐸時期最偉大的編年史作家之一，並以

他大量而詳盡的信件聞名，他曾如此寫道：「我真希望自己尚能寫信給您，但我的右手再次被這可怕的痛風糾纏。」他的個人書寫風格想必更加精湛，但我們還是要求蓋瑞斯讓字體看起來比史實中更優雅一些，因為接下來夏普義會如腳本指示拍死一隻蒼蠅，而我們希望精緻的字體和壓扁的蒼蠅間有強烈的對比。蓋瑞斯的手也演出了打蒼蠅的橋段，道具組為他收集了一整罐蒼蠅屍體，以免需要多次拍攝。

然而，並非所有劇中角色都是書法大師。現實中的亨利八世筆跡尤其凌亂得難以破解，而螢幕上出現他那潦草的人選名單，是經過現代手寫藝術家修改過的，這樣電視觀眾才能看得更清楚。至於亨利的第五位人選，也就是十多歲的凱薩琳，有些歷史學家說她幾乎形同文盲，而為了戲劇效果，我們誇飾了這一點，為她製作一封錯誤百出的信給她的偷情對象卡爾佩珀：「卡爾佩珀，我全芯全意地渴望與你湘聚，並期侍能收到你的回音。」凱薩琳的信後來被視為國王判她死刑的證據，她十九歲便在倫敦塔遭到斬首。

這是我們美術部門實習生梅根·布雷斯林（Megan Breslin）的手寫作品，她負責擔任年輕女王的手部替身，就像之前蓋瑞斯擔任夏普義的替身那樣，她也找來道具員搬來折疊梯站在她頭頂上方，這一次是為了製造她臉上落下的眼淚。雖然梅根原本的字跡十分工整，而且非常擅長使用羽毛筆，但當天有兩個關鍵因素讓梅根的字跡顯得非常潦草。第一個是，她使用了右手來寫信，而非平時習慣的左手，另一個原因則是，她太緊張了，一穿上戲服被帶到片場，她的手就開始不由自主地顫抖。

Master Culpeper I hartely
recommend me vnto youe
praying you to sende me
worde how that yo doo It
was shewed me that you was
seke the wyche thynge trobled
me very muche tell suche
tyme that I here from you
prayng you to send me worde
how that you do for I
never longed so muche for [a]
thynge as I do to se you
and to speake wyth you
the wyche I trust shall
be shortely nowe the wyche
dothe comforthe me verey
muche when I thynk of

good vnto that pore felowe my
man wyche is on of the grefes
that I do depart from hym
for then I do knowe noone that
I dare truste to send to you
and therfor I pray you take
hym to be wyth you that I may
sumtyme here from you one
thynge I pray you to gyve me
a horse from my man for I
had muche ado to get
one and therfore I pray sende
me one by hym and in so
doyng I am as I sade afor and
thus I take my leve of you
trustyng to se you shortely
agine and I wolde ye were
(wt me now) thynke agine

that you shall departe
from me agine yt makes
my harte to dye to thynk
what fortune I have that
I cannot be always yn your
campany yt my trust ys
always in you that you
wolde as yn have promysed
me and in that hope I
truste upon styll, prayinge
yu then that you will com
when my lade Rochforde
here for then I shalbe beste
at leysure to be at your
commandment Thankyng
yu for that you have
promysed me to be so

Yt was shewed me now
that you mothe be word payne
I take yn wryghtyng to you.

yours as long as
lyffe endures

Katheryn

one thyng I had forgotten
and that ys to instruct my man
to tarry here wyth you styll
for he says what so ever you
bed hym wyll do it and

1 Lady Jane Askew
2 Catherine of Ascham
3 Katherine Ashley
4 Anne Stuart
5 Lady Camille of York
6 Margaret Parry
7 Blanche Spencer
8 Annabella Spencer
9 Anne Spencer
10 Elizabeth Willoughby
11 Elizabeth Cecil
12 Lady Catherine Courtenay
13 Elizabeth Marlowe
14 Mary Dudley
15 Lady Jane Denny
16 Lady Victoria Throckmorton
17 Lady Poe Throckmorton
18 Marie de Beaufort
19 Lady Ursula Hardwick
20 Anne Hilliard
21 Jane Hilliard
22 Mary Hepburn
23 Eugenia Latimer
24 Charlotte Paget
25 Beatrice Topcliffe
26 Lady Catherine de Boise

染色與仿舊的紙張 →→

1 無仿舊效果 2 茶 3 漂白劑和檸檬汁 4 擦亮劑 5 過
錳酸鉀結晶 6 咖啡 7 義大利香醋，放入烤箱十分鐘 8
紅酒醋 9 以火柴燃燒

將一張嶄新的白紙浸入茶盤裡，並看著它轉為美麗的仿舊色
澤，這真是件令人滿足的事。美術部門經常需要製作茶漬，
使成堆的文件顯得很舊。但製作茶漬的過程同時也會讓紙張
看起來彷彿曾經掉入水坑，因此我們必須選擇正確的紙張，
並在事後進行妥善的熨燙，好讓紙張再次平整。有些銅版紙
永遠無法重新變平，但手工的美術紙較能吸水，不會變皺。

如果你在愛爾蘭或英國以外的地方工作，買不到便宜無繩的
袋裝茶包，也可以用即溶咖啡來代替。浸泡後的顏色大致上
相同，但會需要泡更久的時間，才能獲得相近的污漬。檸檬
汁則可以去除一些深色紙張上的顏色，使紙張看起來斑駁，
像是經過日曬而發白。而真正的漂白劑則能更顯白，但不能
泡得太久。過錳酸鉀結晶可以製造出點狀污漬的效果，而燒
焦的紙緣則會立刻讓人聯想到海盜船上的文件。

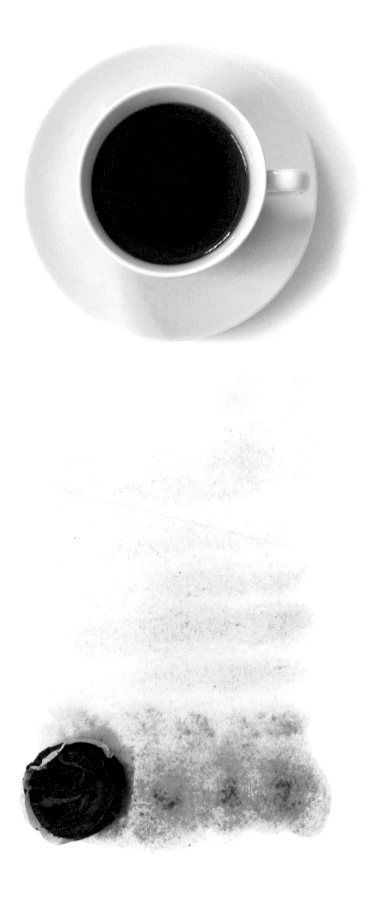

NEW

* TRAN
* CONT
* "HEAD
* {JOPL
* "WIL
 → NA
* NEWS
 (LILI

LOG B

* GUST
* HERR
* HEN
* LIEU
* MUSE

PASS P

M. GUS
AGATH
ZERO
HENO

• PAIN

"BOY
(LESBIA
→ COPY

MAPS

30 SECOND PAPER
5 T × 5 MINS

1 T × 1 MIN

30 SECOND PAPER

POETRY
FICE
KBOOK
MAKE)

0/50
S BASE
OLD FRE
FRAN

K

(WES
SKETC
ARY

FF
NSIGNIA
HAT
ERET

3?

AN MAP FOR TOURIST COUPLE
COMMAND HQ MAP W/ GAME PIECES.

MADAME D'S
LAST WILL + TESTAMENT:
- - - - - - - - - - - - -

HASAKOWA PAPER
10 TEABAGS
1 x KETTLE
5 MINS STEEP TEA
30 SECOND PAPER SOAK.

PACKAGING
PAPER
LUDWIG MAP

REF
B

茶漬效果配方 ←

了解紙張染色的訣竅，就是對每個道具進行實驗，並仔細記下作法。如果我們被要求重新拍攝一份文件，之前卻沒有寫下材料比例和時間，就可能會產生色調不連戲的問題。這張照片上的仿舊配方是用來製作德夫人的遺囑，這份文件看起來必須像是寫於一八八六年，配方則是十個茶包同時浸在茶壺裡五分鐘。

當然，並不是每一部電影中的所有文件都需要仿舊，我們也製作了許多在故事情節中是全新的道具。但為平面道具加上一點點復古效果，可以讓觀眾相信它們是來自古老的年代，而不是在拍攝前一天才在美術部門製作出來。

假血 →

當市面上首度出現瓶裝假血時，顏色是最重要的挑選基準，當時，這些鮮紅的混合物是特別為劇場觀眾製作的。後來有了電影，血液的色調變得更加重要，據說黑白電影創作者會使用巧克力糖漿，好在鏡頭前製造出更強烈的對比效果。現在，我們已經可以根據不同的需求，買到不同的色調和濃稠度的假血。有新鮮明亮的血、流動的血液、滲出的血或粘稠深色的血，視劇情而定，甚至也可以自己用玉米糖漿和食用色素來製作。將血液塗到製作物上通常是道具組的工作，拍攝《歡迎來到布達佩斯大飯店》時，是現場的臨時道具員堤爾‧森南（Till Sennhenn）為每封電報上色，運用好幾種不同的顏色來做出分層效果，並以熱氣噴槍來吹乾它們。不過，平面設計部門還是隨時備個一兩瓶比較方便，畢竟我們永遠不知道，導演什麼時候會要求我們快速提供一份濺血的製作物。

基本工具組

我開設平面道具製作工作坊時，最常被學生問到的問題是：
工具包裡要裝哪些東西？這很難有完美的答案，因為製作淘
金電影和太空電影所需的工具，兩者之間可能會有極大的不
同，所有工具都會隨著時間而累積得越來越多。像我現在
有好幾支封蠟棒，實際上根本不需要這麼多，這些都是我
在《都鐸王朝》工作期間剩下的。除了所有必要的電腦，
包含筆電、掃描機、螢幕、印表機、硬碟，你首先可以準備
的最好工具是一個基本的鉛筆盒，裡面裝著好的鉛筆、鋒利
的刀片、卷尺和一支你喜歡用來畫畫的筆。上圖由左到右依
序是：橡皮擦、削鉛筆器、筆刀、折紙刀、鉛筆、圓規、剪
刀、鐵尺、沾水筆、紅色封蠟、卷尺、墨水、一組針線。

粉紅色卷尺

關於工具，《維京傳奇》（Vikings）的美術指導卡梅爾·紐金特（Carmel Nugent）曾給了我一個很棒的建議。她建議　我用粉紅色指甲油塗滿我的卷尺，這樣製景部門的同事就不會不小心拿錯了。

青少年日記（《金屬之心》）

當我們為電影進行設計時，我們並不一定是用平面設計師的眼光來進行。相反地，我們要站在電影人物的角度看待這些物品。在《金屬之心》（Metal Heart, 2019）中，十六歲的雙胞胎姊妹艾瑪和香塔兒性格迥異，香塔兒是一位成功的網紅和生意人，但艾瑪卻待在一支從未登台演出過的樂團裡，成天作著白日夢。根據劇本描述，艾瑪的日記本上寫滿了她的歌詞、想法和塗鴉。

十六歲的搖滾少女會用什麼來畫畫呢？我們選了一支便宜的黑色鋼珠筆和Tipp-Ex牌的立可白，和Wite-Out牌的很相似。後來，藝術總監尼爾・崔西（Neill Treacy）將筆記本上的塗鴉交給佈景設計師艾倫・蘭伯特（Alan Lambert），請他將塗鴉畫在艾瑪的臥室牆上，彷彿她整個青春期都在天花板和牆壁上畫畫一樣。

固定紙張的文具 →

好的固定文具可以在平面道具上達到畫龍點睛的效果，但我們必須特別小心，不能使用任何與時代不符的文具。例如，目前已知世上第一個訂書機，是在十七世紀專為法王路易十五而製造的。但昂貴的純金訂書針和繁瑣的裝載方式，使得這種工具要一直到一八七〇年代喬治‧麥吉爾（George McGill）重新發明它之後，才開始受到廣泛使用。麥吉爾似乎一生都致力於研究固定紙張的文具，在發明訂書機的前幾年，他還發明了銅製開口銷。

文件繩是一種兩端皆有金屬橫梁的短繩，一九一二年首次出現在英國皇家文書局（Her Majesty's Stationery Office）公開的一份清單上，取代了同是用來捆綁文件的臨時蠟繩。第一個迴紋針則是在一八九九年，由挪威人約翰‧瓦勒（Johan Vaaler）發明，發明之初顯然有各種不同的形狀，他的專利摘要是這樣寫的：「此為彎曲為矩形、三角形或其他形狀的一段金屬絲，或呈環狀，其兩端沿相反方向並排，呈舌狀。」

STAINE...

Stained Glass leadi...
3mm MDF; pain...

Fixed to Pers...
Cathedral ...

A	**B**	**C**	**D**	**E**	**F**	
165 x 122 mm	165 x 574 mm	165 x 574 mm	165 x 574 mm	165 x 574 mm	165 x 574 mm	122
28-off	*4-off*	*2-off*	*4-off*	*2-off*	*2-off*	

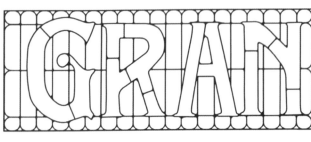

M
1498 x 574 mm
1-off

CERAMIC TILES

Patterned tiles to be printed on vinyl;
Fixed to MDF pieces;
Paint finish as ceramic with scored grout lines.

Q	**R**	**V**	**S**	**T**	**U**
115 x 122 mm	126 x 122 mm	190 x 122 mm	126 x 574 mm	115 x 574 mm	190 x 574 mm
4-off	*8-off*	*8-off*	*4-off*	*2-off*	*4-off*

NB. COLOUR OVERVIEW N.T.S.

Perspex to be painted as Stained Glass with French enamel:

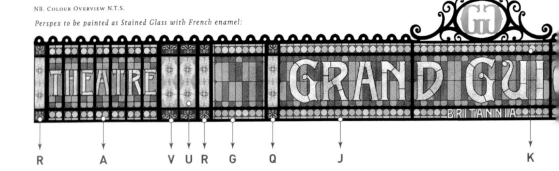

R A V U R G Q J K

180

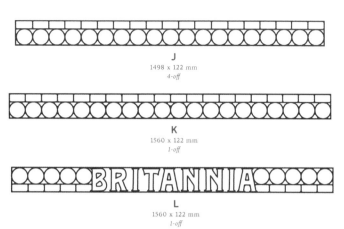

J
1498 x 122 mm
4-off

K
1560 x 122 mm
1-off

H
574 x 605 mm
2-off

L
1560 x 122 mm
1-off

P
1498 x 574 mm
1-off

W
1586 x 492 mm
1-off
ld Steel painted as Black Cast Iron

X
610 x 454 mm
2-off
6mm MDF painted as Black Cast Iron

Y
6483 x 626 mm
1-off
6mm MDF painted as Gold Cast Iron

PENNY DREADFUL					
PRODUCTION DESIGNER: JONATHAN McKINSTRY					
SET Grand Guignol Theatre Ext.				LOC. Dame Lane	
DETAIL Canopy Graphics				DWG No 553 REV (To be read with No 553)	
DRAWN AA	DATE 30.1.14		SET No 3.44		SCALE 20%
PROD	CARPS X	PROPS		PASSED BY	
DIR	PLANT	LOC		J. McKinstry	
CAM	PAINT X	SFX		ISSUED ON 30.1.14	
ELEC	RIGGS	VIS FX			
ART	METAL X	GRAPHICS X		REVISED ON	
C.M X	SET DEC X	SIGNWTR X			

大木偶恐怖劇場門面（《英國恐怖故事》）← ←

當我開始參與許多不同時代背景的電影製作，我為自己定下一個規則，那就是如果某件物品在那個年代是手工製作的，那麼我也要手工將道具製作出來。因為我發現，如果想讓電腦字體看起來像是手寫字，總會花很多不必要的時間，而拿起鉛筆開始手寫，往往是更簡單有效的方法。

《英國恐怖故事》的第三集主要聚焦於維多利亞時代倫敦蘇活區大木偶恐怖劇場一帶。劇中，一位名叫布蘭德的男子，是「一位文質彬彬的演員領班，已過中年，絲毫沒有刻意以華麗的背心來隱藏他的腰圍。」正如編劇約翰·洛根（John Logan）在劇本中所描述的，布蘭德是「這個故事中十分特殊的角色，一開始就討人喜歡」。藝術總監強納森·麥肯斯基（Jonathan McKinstry）指示，大木偶恐怖劇場的門面應該要是布蘭德的性格的延伸：繽紛、華麗與迷人。

我們固然可以使用現有字體來製作劇院招牌，坊間有許多這類裝飾藝術風格的字體可以購買。但我的「手工自製」規則這時就發揮作用了。由於招牌是以彩色玻璃製作的，這也就表示，在那個年代，上面的字體應該是由玻璃師傅親自負責繪製和切割，他們根本不可能見過這個時代的下載字體。還有，招牌頂端有著兩個鍛造的「G」字，這兩個字母的形狀應該要與彩色玻璃上的「G」完全不同，因為鍛造的字母往往可能是由鐵匠設計的。

親手畫出玻璃和瓷磚上的所有字母與圖案，讓這塊招牌顯得更有生命力，也意味著招牌上沒有任何一個字母長得一模一樣。畫完之後，我才開始進行數位化處理，先是掃描並以Adobe Illustrator開啟，然後描圖，再全部轉成向量物件，最後才能做出正確比例的施工圖，提供給玻璃師傅和鐵匠。不過，最後美術指導們決定要用壓克力來取代玻璃元素，因為招牌最後要掛在演員頭頂上，壓克力材質更輕也更安全。而鍛鐵元素也同樣改為了鋼。並在上漆師傅協助下，這些替代材料最終看起來非常逼真，例如，他們將PVA膠水塗在塑膠上，便產生著彩色玻璃斑斕的效果，鋼製品上則黏上許多鐵銹和薄鐵片。

觀眾第一次見到布蘭德，是他醉醺醺地在小巷中撒尿的場景。我們沒有以電腦字型來製作將劇院招牌，而是讓每個字體顯得不太規則，這也正好符合了劇本對布蘭德形象的描述。布蘭德介紹這座建築物時，是這麼說：「在這裡，畸形得以成為優雅，醜陋能化為美麗，所有怪異都將被讚頌而非閃避，這裡就是我的劇場。」

打標膠帶 →

這種獨特的工業字體是以手持打標機和膠帶製成，它們是一九五八年帝摩公司（Dymo）發明的產品。但圖中的這台工具並沒有什麼特殊的地方，只是我二〇一一年時，為了製作某個七〇年代主題的廣告而購買的。這台小機器內涵所有英文字母、十個數字，以及少量標點符號，膠帶則有各種顏色，但如果是要用在諜報電影裡，我通常會選擇紅色或黑色。上面的文字都是白色的，文字是以打凸的方式呈現，而不是使用顏料印在膠帶上。

TOP SECRET

ESPIONAGE

CONFIDENTIAL

CLASSIFIED

INDEX

53.3498N. 6.2603W

小林中的徽章圖案（《犬之島》）

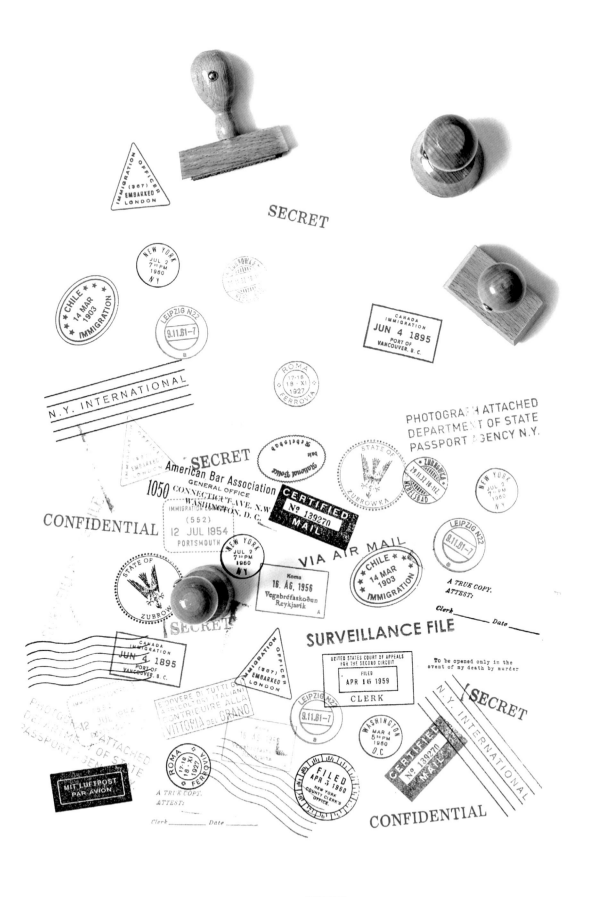

各種圖章

垃圾島緊急命令的版畫字母（《犬之島》）→

我可以花一整天的時間在Photoshop上，試圖刷淡一個電腦繪製的「圖章」，讓它看起來帶有墨水印在紙張上的效果。但直接製作一顆真正的圖章其實更加簡單有效，同樣道理，印刷範本、噴漆和刻字也是如此。雖然電腦裡有各式各樣的數位畫筆和仿舊字體可以創造出類似的效果，但手工製作才是最能還原「手工製作」的方法。不管在哪個城市裡，你都能找到至少一家製作圖章的小店或工廠。我們也盡量選擇木頭而非塑膠的圖章握柄。有位曾經共事過的道具管理員就告訴我，這些實體圖章真的很有用，像是在背景畫面中，臨演如果正扮演飯店接待員或辦公室職員，就可以讓他們拿著這些圖章。臨演總需要動手做點什麼來分散注意力，才不會在漫長的拍攝過程中變得像殭屍一樣。另外，木柄用久了也不會像塑膠材質一樣發黃。

乾式轉印文字 ←

電影平面設計有時就像是一種娛樂，而不是一件工作。其中，乾式轉印的製程更像是玩耍，那些薄塑膠板上的文字貼紙，可以透過摩擦的方式轉印到電影道具上。

在沒有其他轉印方式之前，這個過程聽起來很乏味。我父親布魯斯曾在一九六〇年代攻讀平面設計，在設計學院就讀期間，他就是使用乾式轉印來進行排版，後來這種方式逐漸被數位排版軟體取代，但我父親還是持續使用，直到八〇年代，他任職的設計公司購入了第一台蘋果推出的Mac排版機。

早期，他們會使用拉圖雷塞公司（Letraset）的轉印貼紙來排版，然後再以底片拍攝下來。這個過程後來有所轉變，成為我父親現在認為是「簡單的而標準的作品製程」，作法如下：一、手繪版面，確定內容和所需尺寸。二、選擇字體，並找出相應的字體貼紙。三、開始轉印文字。四、拍下編排好的版面。五、曝光並放大沖洗出這些文字原始尺寸的黑白照片。六、將照片上的文字一一剪下，並用可撕除的萬用黏土來重新將版面排好。他記得他以前任職的倫敦工作室裡，地板上到處都是用到一半的L拉圖雷塞公司貼紙，但總是缺少他們最需要的那幾個字。有時候他會把這些貼紙帶回家送給我，而我則會將那些用剩的字母都轉印筆記本上，在一排排字母「Q」、「X」、「Z」之間，加入許多奇怪的標點符號。

三台打字機 →→

不同的打字機會有不同的字體,因此如果情況許可,最好使用與故事時代背景相符的打字機,雖然有時也不必拘泥於此。這台美麗的奧利維蒂情人打字機是向一位老朋友借的,讓我拿去《間諜橋》劇組使用。這台機器其實是一九六八年製作的,比故事發生的時間晚了十年。但文件上的字體不算是太明顯的穿幫失誤,更重要的是,不能讓人一眼就看出這些打字文件其實是電腦製作的。雖然坊間有一些很棒的字體,是掃描了真實的打字機文字後製作出來的,但直接以真實打字機打出這些文件更好,因為手工打字的文件上多半會有一些錯誤,看起來比較自然,像是有些字母按得比較用力,有些按得太輕,有些則沒有對齊。想想看,在某些電影中,反派的信件中「T」字位置總是比較高,讓警方終於得以解開謀殺之謎。有時候製作背景裝飾而非主角道具時,我們也會使用電腦字體來代替打字機,但最好還是要準備一份真實的打字機文件來當作對照,畢竟,我們可不希望這份偽打字機文件上,出現十八級的超大文字。

義大利奧利維蒂情人打字機,一九六八年(又稱為「紅色便攜式打字機」)

義大利奧利維蒂朵拉打字機，一九七四年

瑞典FACIT TP2打字機，一九六八年

ADMIRABLE

TOILETTE-PAPIER
TUALETES PAPIRS

空白復古紙張 ←·←

我之前還參與製作過另外一部以二戰時代為背景的電影，巧合的是，當時的暫定片名是《艾特金斯小姐的軍隊》（Miss Atkins' s Army）。更巧的是，我那時正好收到一封信，有位來自拉脫維亞（Latvia）的男子，名叫詹尼斯·林德（Janis Linde），說他有一大批一九四〇年代發黃的紙張要出售。真實的舊紙張對電影平面設計部門來說，就像是黃金一樣珍貴，雖然某些道具確實能以染色和熨燙製成，但這些紙張往往還是看得出潮濕甚至是泡水的痕跡。拍攝《歡迎來到布達佩斯大飯店》期間，道具採購艾卡特·弗里茲（Eckart Friz）也曾給了我們三大盒古董紙，是從東德史塔西國安部的舊辦公室搶救下來的，盒裡裝著淡粉色、綠色和黃色的空白紙張，每張邊緣都因暴露在空氣中而略有變色，但其他方面都非常完美。我們用了一些來印製主角道具，因為它們實在太珍貴了，不能用來當作背景裝飾。剩下的則被用在《間諜橋》，幾乎三盒都用光了。

詹尼斯告訴我，他是在大約二十年前，重新裝修他家的花園小房時發現了那些舊紙張。當時，他看到房屋的其中一面外牆比其他牆壁都還要厚，等到牆面拆除時，他發現裡面是中空的，還堆滿一捆又一捆悉心包裝的包裹，最外層的包裝紙則是戰時用來覆蓋窗戶的遮光紙。每個包裹裡，都裝有大量未使用過的空白紙張，有橫線紙、繪圖紙、吸墨紙、樂譜紙，甚至還有從未拆封的鉛筆、鋼筆、筆記本、帳本，和各式各樣的文具和辦公用品，幾乎都是全新狀態。

詹尼斯記得，他的曾祖父赫曼尼斯·厄彭斯（Hermanis Upens）在一九四〇年代時，曾於首都里加（Riga）經營一家文具店。他小時候曾用店裡的鉛筆寫字，還玩過店裡幾盒貴重的撲克牌。文具零售是一個相當繁重的工作，平日紙張的銷售量都非常高，而赫曼尼斯的貨源則來自俄羅斯邊境的利加特內河畔（Līgatne River）的大型造紙廠。這是一個小小的家族企業，但十分忙碌，妻子艾薇拉負責櫃檯，赫曼尼斯則管理所有的後端業務。但當二戰期間蘇聯佔領了拉脫維亞，他們的生計便像大多數的私營企業一樣被剝奪了。詹尼斯的曾祖父母被政府告知，小店即將國有化，若不想被驅逐到勞改營，唯一的方法就是自願交出店面及所有的商品。在所有東西被徵收之前，他們設法將一些文具藏在花園小房空心的牆面裡。蘇聯佔領持續了將近五十年，拉脫維亞的主權直到一九九一年才完全收回。在那期間，赫曼尼斯和艾薇拉都無法再回去工作。

詹尼斯在一九九〇年代發現了他們藏匿的物品，他說，這就像挖到寶藏一樣，但他是在二十年或更長的時間之後，才發覺這些東西可能對某些人、某些地方或某些事情很有幫助。後來他開始自己的事業，製作一些運動感應裝置，他決定聯繫一些電影設計師，看看出售這些紙張能不能貼補一些製作成本。我立刻向他購買了一些庫存，想必世界各地電影業的同事們也都這麼做了。然而，赫曼尼斯與艾薇拉·厄彭斯永遠不會知道他們藏匿的東西後來發生了什麼事。八十年後的今天，他們的曾孫因為這些文具得以為自己的事業融資，而這些張紙偶爾還會在電影中成為主角道具，甚至獲得一個特寫鏡頭。

照片版權

尺寸顯示為：高╳寬╳深

INTRODUCTION

PROTEST SIGNAGE
placards ¾ x 1 in. (2 x 3 cm)
Isle of Dogs (dir. Wes Anderson, 2018)
Production Designers: Paul Harrod &
Adam Stockhausen
Graphic Designer: Annie Atkins
Assistant Graphic Designer: Molly Rosenblatt
Photograph by Flora Fricker
 "ISLE OF DOGS" © 2018 Twentieth Century Fox. All
rights reserved.

ZOLTAR'S CARD
2 x 3½ in. (5 x 8.9 cm)
Big (dir. Penny Marshall, 1988)
Production Designer: Santo Loquasto
Set Decorators: George DeTitta Jr. &
Susan Bode-Tyson
Graphic Designer unknown
 "BIG" © 1988 Twentieth Century Fox.
All rights reserved.

THE TIMES (LONDON, 1945)
24 x 18 in. (61 x 45.7 cm)
Photograph by Flora Fricker
Courtesy The Times / News Licensing

CHAPTER 1

THE GREAT BIG BOOK OF WHEELS AND WINGS
cover 16 x 11 in. (40.6 x 27.9 cm)
Bridge of Spies (dir. Steven Spielberg, 2015)
Production Designer: Adam Stockhausen
Set Decorator: Rena DeAngelo
Property Master: Sandy Hamilton
Graphic Designer: Annie Atkins
Photograph by Flora Fricker
 "BRIDGE OF SPIES" © 2015 Twentieth Century
Fox. All rights reserved. Courtesy of Storyteller
Distribution Co., LLC.

WEST GERMAN FOOD PACKAGING
sugar for scale 5½ x 4 x 2 in.
(14 x 10.2 x 5 cm)
Bridge of Spies (dir. Steven Spielberg, 2015)
Production Designer: Adam Stockhausen
Set Decorator (Germany): Bernhard Henrich
Property Master (Germany): Eckart Friz
Graphic Designers: Annie Atkins &
Liliana Lambriev
Photograph by Flora Fricker
 "BRIDGE OF SPIES" © 2015 Twentieth Century
Fox. All rights reserved. Courtesy of Storyteller
Distribution Co., LLC.

LETTERING SKETCH FOR MILK CARTON
11½ x 8 in. (29.2 x 20.3 cm)
Bridge of Spies (dir. Steven Spielberg, 2015)
Production Designer: Adam Stockhausen
Set Decorator: Rena DeAngelo
Graphic Designer: Annie Atkins
 "BRIDGE OF SPIES" © 2015 Twentieth Century

Fox. All rights reserved. Courtesy of Storyteller
Distribution Co., LLC.

PASSPORT
6 x 3½ in. (15.2 x 8.9 cm)
Bridge of Spies (dir. Steven Spielberg, 2015)
Production Designer: Adam Stockhausen
Set Decorator: Rena DeAngelo
Property Master: Sandy Hamilton
Property Master (Germany): Eckart Friz
Graphic Designers: Annie Atkins &
Liliana Lambriev
Photograph of Tom Hanks as James Donovan by
Jaap Buitendijk
Photograph of passport by Flora Fricker
 "BRIDGE OF SPIES" © 2015 Twentieth Century
Fox. All rights reserved. Courtesy of Storyteller
Distribution Co., LLC.

BOYS' MAGAZINE SPREAD, 1950s
11 x 16 in. (27.9 x 40.6 cm)
Bridge of Spies (dir. Steven Spielberg, 2015)
Production Designer: Adam Stockhausen
Set Decorator: Rena DeAngelo
Property Master: Sandy Hamilton
Graphic Designer: Annie Atkins
Photograph by Flora Fricker
 "BRIDGE OF SPIES" © 2015 Twentieth Century
Fox. All rights reserved. Courtesy of Storyteller
Distribution Co., LLC.

BULLET HOLES
1–3 in. (2.5–7.6 cm) diameter
Bridge of Spies (dir. Steven Spielberg, 2015)
Production Designer: Adam Stockhausen
Art Director (Germany): Marco Bittner Rosser
Graphic Designers: Liliana Lambriev &
Annie Atkins
Photograph by Flora Fricker
 "BRIDGE OF SPIES" © 2015 Twentieth Century
Fox. All rights reserved. Courtesy of Storyteller
Distribution Co., LLC.

THE AMERICAN MUSEUM OF NATURAL HISTORY
FLOOR TILES
1,200 sq. ft. (366 sq. m)
Wonderstruck (dir. Todd Haynes, 2017)
Production Designer: Mark Friedberg
Art Director: Kim Jennings
Assistant Art Director: Michael Auszura
Graphic Designers: Edward A. Ioffreda & Annie
Atkins
Courtesy of Amazon Content Services LLC

ESPIONAGE DOCUMENTS
various sizes: see ruler for scale
Bridge of Spies (dir. Steven Spielberg, 2015)
Production Designer: Adam Stockhausen
Set Decorator: Rena DeAngelo
Set Decorator (Germany): Bernhard Henrich
Property Master: Sandy Hamilton
Property Master (Germany): Eckart Friz
Graphic Designers: Annie Atkins &
Liliana Lambriev
Photograph by Flora Fricker

"BRIDGE OF SPIES" © 2015 Twentieth Century Fox. All rights reserved. Courtesy of Storyteller Distribution Co., LLC.

EIGHTEEN MAPS
2 x 2 in. (5 x 5 cm)
Isle of Dogs (dir. Wes Anderson, 2018)
Production Designers: Paul Harrod & Adam Stockhausen
Graphic Designer: Annie Atkins
Assistant Graphic Designer: Chinami Narikawa
Photograph by Flora Fricker
"ISLE OF DOGS" © 2018 Twentieth Century Fox. All rights reserved.

U-2 PILOT COCKPIT DOCUMENTS
folded maps 6 x 4 in. (15.2 x 10.1 cm)
map with yellow stickers 11 x 6 in. (27.9 x 15.2 cm)
green document 7½ x 4 in. (19 x 10.2 cm)
Bridge of Spies (dir. Steven Spielberg, 2015)
Production Designer: Adam Stockhausen
Property Master: Sandy Hamilton
Property Master (Germany): Eckart Friz
Set Decorator: Rena DeAngelo
Graphic Designers: Annie Atkins & Liliana Lambriev
Photograph by Flora Fricker
"BRIDGE OF SPIES" © 2015 Twentieth Century Fox. All rights reserved. Courtesy of Storyteller Distribution Co., LLC.

SKETCHES OF BOX LABELS
11½ x 8 in. (29.2 x 20.3 cm)
The Boxtrolls (Laika, dir. Graham Annable & Anthony Stacchi, 2014)
Production Designers: Michel Breton, August Hall, Paul Lasaine & Tom McClure
Art Director: Curt Enderle
Graphic Designers: Josh Holtsclaw & Annie Atkins
Reproduced by permission of Laika LLC
© 2012 Laika. All Rights Reserved.

CINEMA TICKETS
1 x 2 in. (2.5 x 5 cm)
Wonderstruck (dir. Todd Haynes, 2017)
Production Designer: Mark Friedberg
Set Decorator: Debra Schutt
Property Master: Sandy Hamilton
Graphic Designer: Annie Atkins
Photograph by Flora Fricker
Courtesy of Amazon Content Services LLC

LONDON ZOO
each sign 12–40 in. high, 24–60 in. wide (30.5–101.6 cm high, 60.9–152.4 cm wide)
monkey info 13 x 24 in. (33 x 61 cm)
Please Do Not Encourage the Monkeys sign 8 x 13 in. (20.3 x 33 cm)
The Gardens of the Zoological Society of London map 33 X 46 in. (84 x 118.9 cm)
Penny Dreadful (Showtime Networks, 2014)
Production Designer: Jonathan McKinstry

Set Decorator: Philip Murphy
Art Director: Colman Corish
Graphic Designer: Annie Atkins
Sign Painter: Laurence O Toole
Courtesy of Showtime Networks Inc.

CHAPTER 2

POESIEALBUM
cover 8 x 5 in. (20.3 x 13 cm)
Photograph by Flora Fricker
Collection of Annie Atkins

PRINTED EPHEMERA
various sizes
Photograph by Flora Fricker
Collection of Annie Atkins

WHITE FIVER FRONT AND BACK
4⅛ x 7⅞ in. (12 x 19.5 cm)
Photograph by Flora Fricker
Collection of Annie Atkins

GOODS INVOICE: FABRIC DYING COMPANY
(Manchester, England, 1936)
7 x 8 in. (17.8 x 20.3 cm)
Photograph by Flora Fricker
Collection of Annie Atkins

SELECTION OF OBSERVER POCKET BOOKS
(England, 1937–c. 1960)
each 5½ x 3½ in. (14 x 8.9 cm)
Photograph by Flora Fricker
Collection of Annie Atkins

TELEGRAM (ENGLAND, 1941)
5 x 8 in. (12.7 x 20.3 cm)
Photograph by Flora Fricker
Collection of Annie Atkins

MILK-BOTTLE TOPS (ENGLAND, 1950s)
1½ in. (3.8 cm) diameter
Photograph by Flora Fricker
Collection of Annie Atkins

DEED WRITTEN ON VELLUM (ENGLAND, 1813)
15 x 24 in. (38 x 61 cm)
Photograph by Flora Fricker
Collection of Annie Atkins

CHALLENGE: A HANDWRITTEN MANUSCRIPT BY VITA SACKVILLE-WEST
12½ x 8 in. (31.75 x 20.3 cm)
Photograph by Flora Fricker
Reprinted with kind permission of the Dobkin Family Collection of Feminism
CINEMA TICKETS (CAIRO, EGYPT, EARLY 1940s)
2¼ x 3½ in. (5.7 x 8.9 cm)
Photograph by Flora Fricker
Collection of Annie Atkins

THE RMS TITANIC WITH FOUR WORKING

FUNNELS
18 x 72 in. (45.7 x 183 cm)
Titanic: Blood and Steel (dir. Ciaran Donnelly,
2012)
Production Designer: Tom Conroy
Art Director: Colman Corish
Set Decorator: Jil Turner
Graphic Designer: Annie Atkins
Photograph by Flora Fricker
Two drawings of The RMS Lusitania (fore and aft)
adapted and reprinted with kind permission of
the National Records of Scotland and University of
Glasgow Archives & Special Collections, Upper Clyde
Shipbuilders collection, GB 248 UCS 1/110/367/20
Courtesy of Epos Films Ltd.

SKETCHES FOR SCIENCE FICTION
ICONOGRAPHY
11 x 8½ in. (28 x 21.6 cm)
Annie Atkins' s studio

CHAPTER 3

LETTERING SKETCHES FOR HOTEL SIGNAGE
11½ x 8 in. (29.2 x 20.3 cm)
The Grand Budapest Hotel (dir.
Wes Anderson, 2014)
Production Designer: Adam Stockhausen
Set Decorator: Anna Pinnock
Supervising Art Director: Gerald Sullivan
Art Director: Stephan O. Gessler
Graphic Designer: Annie Atkins
 "THE GRAND BUDAPEST HOTEL" © 2014

THE MENDL' S BOX
5 x 5 x 5 in. (13 x 13 x 13 cm)
The Grand Budapest Hotel (dir.
Wes Anderson, 2014)
Production Designer: Adam Stockhausen
Set Decorator: Anna Pinnock
Property Master: Robin L. Miller
Graphic Designers: Annie Atkins &
Liliana Lambriev
Additional illustration: Jan Jericho
Photograph by Flora Fricker
 "THE GRAND BUDAPEST HOTEL" © 2014

THREE KLUBECK BANKNOTES
largest 5 x 7½ in. (12.7 x 19 cm)
The Grand Budapest Hotel (dir.
Wes Anderson, 2014)
Production Designer: Adam Stockhausen
Set Decorator: Anna Pinnock
Property Master: Robin L. Miller
Graphic Designers: Annie Atkins &
Liliana Lambriev
Additional illustration: Miguel Schmid
Photograph by Flora Fricker
 "THE GRAND BUDAPEST HOTEL" © 2014

ZUBROWKAN POSTAGE STAMPS
sheet 11½ x 8 in. (29.2 x 20.3 cm);
stamp 1¼ x 1 in. (3.3 x 2.5 cm)
The Grand Budapest Hotel (dir.
Wes Anderson, 2014)
Production Designer: Adam Stockhausen
Set Decorator: Anna Pinnock
Graphic Designers: Annie Atkins &
Liliana Lambriev
Illustration: Jan Jericho & Miguel Schmid
Photograph by Flora Fricker
 "THE GRAND BUDAPEST HOTEL" © 2014

LUDWIG' S PRISON ESCAPE MAP
unfolded 18½ x 16 in. (47 x 40.6 cm)
The Grand Budapest Hotel (dir.
Wes Anderson, 2014)
Production Designer: Adam Stockhausen
Set Decorator: Anna Pinnock
Property Master: Robin L. Miller
Graphic Designers: Annie Atkins &
Liliana Lambriev
Additional illustration: Miguel Schmid &
Jan Jericho
Photograph by Flora Fricker
 "THE GRAND BUDAPEST HOTEL" © 2014

SKETCHES FOR KEY FOB DESIGNS
11½ x 8 in. (29.2 x 20.3 cm)
The Grand Budapest Hotel (dir.
Wes Anderson, 2014)
Production Designer: Adam Stockhausen
Set Decorator: Anna Pinnock
Property Master: Robin L. Miller
Graphic Designer: Annie Atkins
Photograph by Flora Fricker
 "THE GRAND BUDAPEST HOTEL" © 2014

LUGGAGE TAGS
approx. 3 in. wide (7.6 cm wide)
The Grand Budapest Hotel (dir.
Wes Anderson, 2014)
Production Designer: Adam Stockhausen
Set Decorator: Anna Pinnock
Property Master: Robin L. Miller
Graphic Designers: Annie Atkins &
Liliana Lambriev
Photograph by Flora Fricker
 "THE GRAND BUDAPEST HOTEL" © 2014

1960s RESTAURANT MENU
12½ x 8 in. (30.5 x 20.3 cm)
The Grand Budapest Hotel (dir.
Wes Anderson, 2014)
Production Designer: Adam Stockhausen
Set Decorator: Anna Pinnock
Property Master: Robin L. Miller
Graphic Designers: Annie Atkins &
Liliana Lambriev

Illustrator: Mary Heneghan
Calligrapher: Jan Jericho
Photograph by Flora Fricker
 "THE GRAND BUDAPEST HOTEL" © 2014
Twentieth Century Fox. All rights reserved.

GUSTAVE'S DEPOSITION
8 x 5½ in. (20.3 x 14 cm)
The Grand Budapest Hotel (dir.
Wes Anderson, 2014)
Production Designer: Adam Stockhausen
Set Decorator: Anna Pinnock
Property Master: Robin L. Miller
Graphic Designers: Annie Atkins &
Liliana Lambriev
Additional illustration: Miguel Schmid
Photograph by Flora Fricker
 "THE GRAND BUDAPEST HOTEL" © 2014
Twentieth Century Fox. All rights reserved.

THE LAST WILL AND TESTAMENT OF MADAME D.
15 x 9 in. (38.1 x 22.9 cm)
The Grand Budapest Hotel (dir.
Wes Anderson, 2014)
Production Designer: Adam Stockhausen
Set Decorator: Anna Pinnock
Property Master: Robin L. Miller
Graphic Designers: Annie Atkins &
Liliana Lambriev
Photograph by Flora Fricker
 "THE GRAND BUDAPEST HOTEL" © 2014
Twentieth Century Fox. All rights reserved.

MADAME D.'S NOTE TO GUSTAVE
8 x 6 in. (20.3 x 15.2 cm)
The Grand Budapest Hotel (dir.
Wes Anderson, 2014)
Production Designer: Adam Stockhausen
Set Decorator: Anna Pinnock
Property Master: Robin L. Miller
Graphic Designers: Annie Atkins &
Liliana Lambriev
Art Department Assistant: Molly Rosenblatt
Photograph by Flora Fricker
 "THE GRAND BUDAPEST HOTEL" © 2014
Twentieth Century Fox. All rights reserved.

BOOK OF ROMANTIC POETRY, VOL. I
8 x 5 in. (20.3 x 12.7 cm)
The Grand Budapest Hotel (dir.
Wes Anderson, 2014)
Production Designer: Adam Stockhausen
Set Decorator: Anna Pinnock
Property Master: Robin L. Miller
Graphic Designers: Annie Atkins &
Liliana Lambriev
Photograph by Flora Fricker
 "THE GRAND BUDAPEST HOTEL" © 2014
Twentieth Century Fox. All rights reserved.

JOPLING'S CALLING CARD
2 x 3½ in. (5.1 x 8.9 cm)
The Grand Budapest Hotel (dir.
Wes Anderson, 2014)

Production Designer: Adam Stockhausen
Set Decorator: Anna Pinnock
Property Master: Robin L. Miller
Graphic Designers: Annie Atkins &
Liliana Lambriev
Art Department Assistant: Miguel Schmid
Photograph by Flora Fricker
 "THE GRAND BUDAPEST HOTEL" © 2014
Twentieth Century Fox. All rights reserved.

TRANS-ALPINE YODEL
9½ x 12½ in. (24.1 x 31.8 cm)
The Grand Budapest Hotel (dir.
Wes Anderson, 2014)
Production Designer: Adam Stockhausen
Set Decorator: Anna Pinnock
Property Master: Robin L. Miller
Graphic Designers: Annie Atkins &
Liliana Lambriev
Photograph by Flora Fricker
 "THE GRAND BUDAPEST HOTEL" © 2014
Twentieth Century Fox. All rights reserved.

PRESS POSTERS
21 x 15 in. (53.3 x 38.1 cm)
The Grand Budapest Hotel (dir.
Wes Anderson, 2014)
Production Designer: Adam Stockhausen
Set Decorator: Anna Pinnock
Property Master: Robin L. Miller
Graphic Designer: Annie Atkins
Photographs by Flora Fricker
 "THE GRAND BUDAPEST HOTEL" © 2014
Twentieth Century Fox. All rights reserved.

POLICE REPORT
9½ x 8 in. (24.1 x 20.3 cm)
The Grand Budapest Hotel (dir.
Wes Anderson, 2014)
Production Designer: Adam Stockhausen
Set Decorator: Anna Pinnock
Property Master: Robin L. Miller
Graphic Designers: Annie Atkins &
Liliana Lambriev
Photograph of Jeff Goldblum as Deputy Kovacs by
Martin Scali
Photograph of prop by Flora Fricker
 "THE GRAND BUDAPEST HOTEL" © 2014
Twentieth Century Fox. All rights reserved.

THE GRAND BUDAPEST HOTEL BOOK
8 x 5 in. (20.3 x 12.7 cm)
The Grand Budapest Hotel (dir.
Wes Anderson, 2014)
Production Designer: Adam Stockhausen
Set Decorator: Anna Pinnock
Property Master: Robin L. Miller
Graphic Designers: Annie Atkins &
Liliana Lambriev
Photograph by Flora Fricker
 "THE GRAND BUDAPEST HOTEL" © 2014
Twentieth Century Fox. All rights reserved.

CHAPTER 4

FORTY-NINE TICKETS
1 X 2 in. (2.5 x 5 cm)
Photograph by Flora Fricker
Annie Atkins's studio

TWELVE YELLOW TELEGRAMS
4½ x 6 in. (11.4 x 15.2 cm)
The Grand Budapest Hotel (dir. Wes Anderson,
2014)
Production Designer: Adam Stockhausen
Set Decorator: Anna Pinnock
Property Master: Robin L. Miller
Graphic Designers: Annie Atkins &
Liliana Lambriev
Photograph by Flora Fricker
"THE GRAND BUDAPEST HOTEL" © 2014
Twentieth Century Fox. All rights reserved.

MULTICOLOR SCRIPT PAGES FROM THE
SHREDDER AT THE END OF A SHOOT
each page 11¾ x 8¼ in. (29.7 x 21 cm)
Photograph by Flora Fricker

LOVE LETTERS: CONTINUITY REPEATS
3 x 5 in. (7.6 x 12.7 cm)
The Tudors (Showtime Networks, 2008)
Production Designer: Tom Conroy
Set Decorator: Crispian Sallis
Graphic Designer: Annie Atkins
Photograph by Megan K. Jones
Courtesy of TM Productions Ltd.

SKETCHES OF TWO US FLAGS
11 x 8½ in. (28 x 21.6 cm)
Annie Atkins's studio

EIGHT COFFEE STAINS
7 x 4 in. (17.8 x 10.1 cm)
Photograph by Mairead Lambert
Collection of Annie Atkins

FOURTEEN ENVELOPES
each 4 x 6½ in. (11.4 x 15.2 cm)
Vita & Virginia (dir. Chanya Button, 2017)
Production Designer: Noam Piper
Art Director: Neill Treacy
Graphic Designers: Felix McGinley &
Annie Atkins
Calligrapher: Sarah O'Dea
Photograph by Flora Fricker
Courtesy of Blinder Films
TWELVE MIX TAPES
3 x 4 in. (7.6 x 10.2 cm)
Photograph by Ailsa Williams
Collection of Annie Atkins

CHAPTER 5

"STEWED EELS & MASHED POTATOES:

ALWAYS READY" ARCHIVAL PHOTOGRAPH
Courtesy of Heritage England/London
Metropolitan Archives

SKETCH FOR SIGNAGE
11½ x 8 in. (29.2 x 20.3 cm)
Penny Dreadful (Showtime Networks, 2014)
Production Designer: Jonathan McKinstry
Graphic Designer: Annie Atkins
Photograph by Flora Fricker
Courtesy of Showtime Networks Inc.
and Annie Atkins studio

STREET POSTER: CHOLERA!
10½ x 8 in. (26.7 x 20.3 cm)
Grand Guignol theater frontage
Penny Dreadful (Showtime Networks, 2014)
Production Designer: Jonathan McKinstry
Graphic Designer: Annie Atkins
Photograph by Flora Fricker
Courtesy of Showtime Networks Inc.

SKETCH FOR DENTIST'S SIGN
11½ x 8 in. (29.2 x 20.3 cm)
Penny Dreadful (Showtime Networks, 2014)
Production Designer: Jonathan McKinstry
Graphic Designer: Annie Atkins
Courtesy of Showtime Networks Inc.
and Annie Atkins studio

SKETCH FOR UNDERTAKER'S SIGN
11½ x 8 in. (29.2 x 20.3 cm)
Penny Dreadful (Showtime Networks, 2014)
Production Designer: Jonathan McKinstry
Graphic Designer: Annie Atkins
Courtesy of Showtime Networks Inc.
and Annie Atkins studio

HOW TO WRITE TELEGRAMS PROPERLY
6 x 4 in. (15.2 x 10.2 cm)
Titanic: Blood and Steel (2012)
Production Designer: Tom Conroy
Set Decorator: Jil Turner
Graphic Designer: Annie Atkins
Photograph by Flora Fricker
Courtesy of Epos Films Ltd.

TITANIC MENUS
large 7¼ x 5 in. (18.3 x 12.7);
small 5½ x 3½ in. (14 x 8.9 cm)
Titanic: Blood and Steel (2012)
Production Designer: Tom Conroy
Set Decorator: Jil Turner
Graphic Designer: Annie Atkins
Photograph by Flora Fricker
Courtesy of Epos Films Ltd.

SKETCH FOR PAWNBROKER'S SHOP WINDOW
11½ x 8 in. (29.2 x 20.3 cm)
Penny Dreadful (Showtime Networks, 2014)
Production Designer: Jonathan McKinstry
Graphic Designer: Annie Atkins
Courtesy of Showtime Networks Inc.
and Annie Atkins studio

NEW YORK SUBWAY SIGNS
various sizes
Bridge of Spies (dir. Steven Spielberg, 2015)
Production Designer: Adam Stockhausen
Supervising Art Director: Kim Jennings
Graphic Designer: Annie Atkins
 "BRIDGE OF SPIES" © 2015 Twentieth Century
Fox. All rights reserved. Courtesy
of Storyteller Distribution Co., LLC.

SKETCH FOR GUNMAKER'S
SIGN
11½ x 8 in. (29.2 x 20.3 cm)
Penny Dreadful (Showtime Networks, 2014)
Production Designer: Jonathan McKinstry
Graphic Designer: Annie Atkins
Courtesy of Showtime Networks Inc.
and Annie Atkins studio

STREET POSTER: THE MATCHGIRL'S STRIKE
10½ x 8 in. (26.7 x 20.3 cm)
Penny Dreadful (Showtime Networks, 2014)
Production Designer: Jonathan McKinstry
Graphic Designer: Annie Atkins
Photograph by Flora Fricker
Courtesy of Showtime Networks Inc.

BACKSTAGE SIGN
13 x 12 in. (33 x 30.5 cm)
Penny Dreadful (Showtime Networks, 2014)
Production Designer: Jonathan McKinstry
Graphic Designer: Annie Atkins
Sign Painter: Laurence O Toole
Photograph by Flora Fricker
Courtesy of Showtime Networks Inc.

THEATER SIGN
11½ x 8 in. (29.2 x 20.3 cm)
Penny Dreadful (Showtime Networks, 2014)
Production Designer: Jonathan McKinstry
Graphic Designer: Annie Atkins
Courtesy of Showtime Networks Inc.
and Annie Atkins studio

HOTEL MATCHBOX & STATIONERY
vintage US letter 10½ x 8 in.
(26.7 x 20.3 cm)
matchbox 1¼ x 2 in (3.4 x 5 cm)
Bridge of Spies (dir. Steven Spielberg, 2015)
Production Designer: Adam Stockhausen
Set Decorator: Rena DeAngelo
Graphic Designer: Annie Atkins
Photograph by Flora Fricker
 "BRIDGE OF SPIES" © 2015 Twentieth Century
Fox. All rights reserved. Courtesy
of Storyteller Distribution Co., LLC.

STREET SIGNAGE
various sizes, 2–6 ft. high (.6–1.8 m)
Bridge of Spies (dir. Steven Spielberg, 2015)
Production Designer: Adam Stockhausen
Supervising Art Director: Kim Jennings
Graphic Designer: Annie Atkins

 "BRIDGE OF SPIES" © 2015 Twentieth Century
Fox. All rights reserved. Courtesy
of Storyteller Distribution Co., LLC.

CAFÉ MENU
20 x 10 in. (50.8 x 25.4 cm)
Penny Dreadful (Showtime Networks, 2014)
Production Designer: Jonathan McKinstry
Graphic Designer: Annie Atkins
Photograph by Flora Fricker
Courtesy of Showtime Networks Inc.

SKETCHES FOR JAPANESE CHARACTERS
11½ x 8 in. (29.2 x 20.3 cm)
Isle of Dogs (dir. Wes Anderson, 2018)
Production Designers: Paul Harrod &
Adam Stockhausen
Art Director: Curt Enderle
Graphic Designers: Erica Dorn & Annie Atkins
 "ISLE OF DOGS" © 2018 Twentieth Century Fox.
All rights reserved.

CHAPTER 6

THREADS AND RIBBONS
Photograph by Flora Fricker
Collection of Annie Atkins

CHAPUYS'S LETTER
14 x 10 in. (35.6 x 25.4 cm)
The Tudors (Showtime Networks, 2008)
Production Designer: Tom Conroy
Set Decorator: Crispian Sallis
Graphic Designer: Annie Atkins
Calligrapher: Gareth Colgan
Photograph by Flora Fricker
Courtesy of TM Productions Ltd.

TUDOR COLLECTION
largest manuscript for scale 18 x 36 in.
(45.7 x 91.4 cm)
The Tudors (Showtime Networks, 2008)
Production Designer: Tom Conroy
Set Decorator: Crispian Sallis
Graphic Designer: Annie Atkins
Photograph by Flora Fricker
Courtesy of TM Productions Ltd.

KATHERINE HOWARD'S LETTER
5 x 3½ in. (12.7 x 8.9 cm)
The Tudors (Showtime Networks, 2008)
Production Designer: Tom Conroy
Set Decorator: Crispian Sallis
Graphic Designer: Annie Atkins
Calligrapher: Megan Breslin
Photograph by Flora Fricker
Courtesy of TM Productions Ltd.

HENRY VIII'S LIST OF POTENTIAL SUITORS
14 x 4½ in. (35.6 x 11.4 cm)
The Tudors (Showtime Networks, 2008)
Production Designer: Tom Conroy

Set Decorator: Crispian Sallis
Graphic Designer: Annie Atkins
Calligrapher: Gareth Colgan
Photograph by Flora Fricker
Courtesy of TM Productions Ltd.

STAINING AND AGING PAPER
Photographs by Flora Fricker
Collection of Annie Atkins

TEA-STAINING RECIPES
Photographs by Flora Fricker
Collection of Annie Atkins

FAKE BLOOD
Photograph by Flora Fricker
Collection of Annie Atkins

BASIC KIT
Photograph by Flora Fricker
Collection of Annie Atkins

PINK MEASURING TAPE
Photograph by Flora Fricker
Collection of Annie Atkins

TEENAGE DIARY
7 x 5 in. (17.8 x 12.7 cm)
Metal Heart (Dir. Hugh O'Conor, 2018)
Production Designer: Neill Treacy
Graphic Designer: Annie Atkins
Photograph by Flora Fricker
Courtesy of Rubicon Films

PAPER FASTENINGS
Photograph by Flora Fricker
Collection of Annie Atkins

GRAND GUIGNOL THEATER FRONTAGE
theater front 16 ft. wide (4.9 m)
Penny Dreadful (Showtime Networks, 2014)
Production Designer: Jonathan McKinstry
Supervising Art Director: Adam O'Neill
Graphic Designer: Annie Atkins
Sign Painters: Laurence O Toole &
Kenneth Carroll
Courtesy of Showtime Networks Inc.

EMBOSSING TAPE LETTERING
Photograph by Flora Fricker
Collection of Annie Atkins
ATARI'S STENCILED EMBLEM
8⅜x 6 in. wide (21.3 x 15.2 cm)
Isle of Dogs (dir. Wes Anderson, 2018)
Production Designers: Paul Harrod &
Adam Stockhausen
Graphic Designers: Erica Dorn & Annie Atkins
"ISLE OF DOGS" © 2018 Twentieth Century Fox.
All rights reserved.

VARIOUS RUBBER STAMPS
approx. 1–2 in. (2.5–5 cm)
Photograph by Flora Fricker
Collection of Annie Atkins

LINOCUT LETTERS FOR THE TRASH ISLAND
DECREE
each letter 2 x 2 in. (5 x 5 cm)
Isle of Dogs (dir. Wes Anderson, 2018)
Production Designers: Paul Harrod &
Adam Stockhausen
Graphic Designers: Erica Dorn & Annie Atkins
Photograph by Flora Fricker
"ISLE OF DOGS" © 2018 Twentieth Century Fox.
All rights reserved.

DRY-TRANSFER LETTERING
Photograph by Flora Fricker
Collection of Annie Atkins

THREE TYPEWRITERS
OLIVETTI VALENTINE (1968)
Photograph by Bruce Atkins
Collection of John Gloyne

OLIVETTI DORA (1974)
Photograph by Flora Fricker
Collection of Annie Atkins

FACIT TP2 (1968)
Photograph by Flora Fricker
Collection of Dympna Treacy

BLANK ANTIQUE PAPER
(various sizes)
Photograph by Flora Fricker
Collection of Annie Atkins

致謝
獻給尼爾與瑪邦

我懷孕的時候正好在進行這本書的提案，到了孩子過完三歲生日的一週之後，終於完成了最後修改版本。多虧了我的公婆塔德格與蒂普娜‧崔西，我才有時間完成這本書。每當我抽空跑去工作時，我都知道孩子正被幸福地呵護著，這真的很重要，沒有他們兩位，這本書就無法順利出版。謝謝你們！

謝謝所有在我寫作期間到工作室幫忙的人，梅根‧布雷斯林、芙拉維亞‧巴拉林（Flavia Ballarin）、喬治‧庫倫（Gregory Cullen）、凱倫‧肯尼（Karen Kenny）、朱爾斯‧加瓦里（Jules Gawlik）、洛琳‧康沃爾（Laurine Cornuéjols）、露西‧沃爾夫（Lucie Wolfe）、露西‧麥卡盧（Lucy McCullough）、馬貝爾‧迪利威（Mabel Dilliway）、瑞秋‧麥凱布（Rachael McCabe）、梅根‧瓊斯（Megan Jones）、路易斯‧卡瓦里奧（Luís Calvário）、山繆‧托梅（Samuel Tomé）、蘿絲‧蒙格馬利（Rose Montgomery）和凱蒂‧加爾文（Katy Galvin），你們為這本書每一章節付出了這麼多，感謝你們為了完成這一切而如此努力。還要感謝詹姆斯‧凱萊赫（James Kelleher）和瓦爾吉‧瓦迪瑪森（Valgeir Valdimarsson）的智慧，也謝謝艾莉莎‧威廉斯（Ailsa Williams）和艾倫‧蘭伯特，他們對這本書作出的貢獻對我而言非常寶貴，他們讓我的工作室每天都更有創造力。另外也要感謝瑪麗德‧蘭伯特（Mairead Lambert），自從她開始和我一起工作之後，她一直表現得非常出色，無論是她對這本書敏銳的研究，或是在我埋首於寫稿的時候，在工作室裡協助我處理這麼多的設計工作。

我還要感謝我在世界各地的電影製作同事們，謝謝他們和我分享各自對書中這些作品的觀點和記憶，平面設計師莉莉安娜‧蘭布里夫、道具員堤爾‧森南、美術指導艾琳‧歐布萊恩（Irene O'Brien）及和庫曼‧寇許（Colman Corish）、搭景師喬治‧德帝塔、蘇珊‧博多、泰森和安娜‧平諾克，以及道具管理師羅賓‧米勒、艾卡特‧弗里茲和珊蒂‧漢米爾頓。更要特別感謝藝術總監亞當‧斯托克豪森、導演魏斯‧安德森導演和監製傑瑞米‧道森（Jeremy Dawson），在《歡迎來到布達佩斯大飯店》劇組工作是足以改變人生的一段經歷，我每一天都感謝自己有幸能為這部如此美麗的電影作出貢獻，也很開心我能在這本書中分享一些當時的作品。我還要感謝藝術總監湯姆‧克羅伊讓我有機會進入製片業，當時的我還是一個年輕稚嫩的電影學院畢業生，也謝謝才華洋溢的皮拉爾‧瓦倫西亞教了我這麼多工藝技法，感謝搭景師克里斯皮安‧沙利斯教導我關注細節的竅門。我也由衷感謝彼亞尼‧艾納松（Bjarni Einarsson）、尼爾森‧羅瑞（Nelson Lowry）和費歐娜‧麥肯（Fiona McCann），你們的才華對我來說非常重要。

謝謝我傑出的編輯莎拉‧巴德（Sara Bader），是你讓這本書成真，感謝你所付出的專業知識，並在整個創作過程中，一直引導著這本書往正確方向前進。我還要感謝發行人的黛比‧亞倫森（Deb Aaronson）從一開始就大力支持這個構想，謝謝美編梅根‧貝內特（Meagan Bennett）將書編排的如此美麗，謝謝攝影師芙蘿拉‧弗里克（Flora Fricker）拍下所有美妙的照片，你是一位如此出色的道具製作者、平面設計師和藝術家。也感謝朱莉亞‧哈斯汀（Julia Hasting），謝謝你為這本書想出這麼酷的設計理念，並選擇「Courier Sans」字體，我從沒想過要用它，但成果非常完美。

最後，感謝我的母親瑪麗‧海內漢（Mary Heneghan）和父親布魯斯‧艾特金斯，他們是我最初的設計導師。我也想用這本書來紀念他們的老友，藝術家彼得‧普倫德格斯特，他的創作哲學始終一路伴隨著我前進。

電影道具大師設計學

Fake Love Letters, Forged Telegrams,and Prison Escape Maps
Designing Graphic Props for Filmmaking

偽情書、假電報與越獄地圖、電影道具平面設計；
置身電影幕後，一窺平面道具非凡而細緻的設計

作　　　　者／安妮‧艾特金斯 Annie Atkins
譯　　　　者／劉佳澐
責 任 編 輯／賴曉玲
版　　　權／黃淑敏、吳亭儀
行 銷 業 務／周佑潔、王瑜、華華
總　編　輯／徐藍萍
總　經　理／彭之琬
事業群總經理／黃淑貞
發　行　人／何飛鵬
法 律 顧 問／元禾法律事務所　王子文律師
出　　　版／商周出版
　　　　　　地址：台北市中山區104民生東路二段141號9樓
　　　　　　電話：(02) 2500-7008　傳真：(02)2500-7759
　　　　　　E-mail：bwp.service@cite.com.tw
發　　　行／英屬蓋曼群島商家庭傳媒股份有限公司城邦分公司
　　　　　　台北市中山區104民生東路二段141號2樓
　　　　　　書虫客服服務專線：02-2500-7718‧02-2500-7719
　　　　　　24小時傳真服務：02-2500-1990‧02-2500-1991
　　　　　　服務時間：週一至週五09:30-12:00‧13:30-17:00
　　　　　　郵撥帳號：19863813　戶名：書虫股份有限公司
　　　　　　讀者服務信箱：service@readingclub.com.tw
　　　　　　城邦讀書花園：www.cite.com.tw
香 港 發 行 所／城邦（香港）出版集團有限公司
　　　　　　香港灣仔駱克道193號東超商業中心1樓
　　　　　　E-mail：hkcite@biznetvigator.com
　　　　　　電話：（852）25086231　傳真：（852）25789337
馬 新 發 行 所／城邦(馬新)出版集團
　　　　　　Cité (M) Sdn. Bhd.
　　　　　　41, Jalan Radin Anum, Bandar Baru Sri Petaling,
　　　　　　57000 Kuala Lumpur, Malaysia
　　　　　　電話：（603）9057-8822　傳真：（603）9057-6622
封面&內頁設計／張福海
印　　　刷／卡樂製版印刷事業有限公司
總　經　銷／聯合發行股份有限公司
地　　　址／新北市231新店區寶橋路235巷6弄6號2樓
　　　　　　電話：（02）2917-8022
　　　　　　傳真：（02）2911-0053
■2021年03月04日初版　　　　　Printed in Taiwan
定價／680元　　　　　　　　　ISBN 978-986-477-989-5
著作權所有‧翻印必究　All rights reserved

國家圖書館出版品預行編目 (CIP) 資料

電影道具大師設計學：偽情書、假電報與越獄地
圖、電影道具平面設計；置身電影幕後，一窺平面
道具非凡而細緻的設計／安妮．艾特金斯 (Annie
Atkins) 著；劉佳澐譯 .-- 初版 .-- 臺北市：商周
出版：英屬蓋曼群島商家庭傳媒股份有限公司城邦
分公司發行, 2021.03 面；公分
譯自：Fake love letters, forged telegrams, and
prison escape maps : designing graphic props
for filmmaking
ISBN 978-986-477-989-5（平裝）
1. 電影美術設計 2. 平面設計
987.3　　　110000529

如果沒有以下這些人的幫助，這本書是不可能完成的：